IMAGES
of America

STERLING

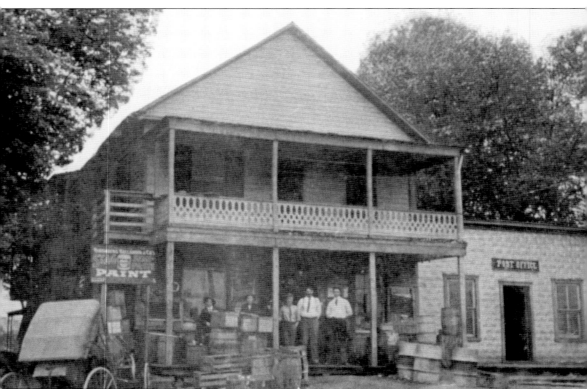

This photograph, from a postcard mailed on March 18, 1913, shows the Sterling Emporium Co., one of Sterling's earliest photographed businesses. Henry Ellmore, pictured at the right, owned the store located near Sterling's railroad station and lived in quarters above it; here, he stands with Raymond Thornsberry, left, and Scott Beavers, center, also Sterling residents. According to the *Loudoun Times-Mirror*, "The store operated until the 1930s and after that the building was structured for apartment living and served this purpose until the early 1970s. When the building was no longer usable, the fire department was delegated to burn it down." (Courtesy of the Crosen family archives.)

On the Cover: A man heads back to the post office after the last mail run from Sterling on May 31, 1957. (Courtesy of the Crosen family archives.)

IMAGES
of America

STERLING

Brittany DeLong
Foreword by Charles Waddell

ARCADIA
PUBLISHING

Published by Arcadia Publishing
Charleston, South Carolina

Printed in the United States of America

Library of Congress Control Number: 2023946463

For all general information, please contact Arcadia Publishing:
Telephone 843-853-2070
Fax 843-853-0044
E-mail sales@arcadiapublishing.com
For customer service and orders:
Toll-Free 1-888-313-2665

Visit us on the Internet at www.arcadiapublishing.com

This book is dedicated to the memories of three Sterling leaders who were instrumental in shaping the community: George Barton (1944–2012), Danny Ford (1956–2020), and Charles Waddell (1932–2022).

CONTENTS

FOREWORD

Sterling, Virginia, has been my hometown for over 60 years. I was present for the evolution of this community from a tiny village to a thriving suburban area of Eastern Loudoun County. My path to Sterling started with my brother, Myron "Rube" Waddell. Rube was discharged from the Marine Corps in 1945 at the end of World War II and, along with his new wife Josephine, settled in Washington, DC. Rube was hired by the US Post Office as a mail clerk and dispatcher at Washington National Airport but soon began longing for a quieter life as a rural mail carrier somewhere in Virginia. Consequently, he contacted then-Congressman Joel Broyhill for assistance in helping locate a vacancy. In early 1955, a vacancy was posted for Sterling, Virginia, a tiny village about 30 miles northwest of Washington, DC, and Rube was chosen as the new rural mail carrier on Route 1.

In the meantime, during the mid- to late 1950s, the Eisenhower administration was searching for a site for a new mega-airport to accommodate the big jets due out in 1959. A site was tentatively selected at Burke, Virginia, and land was beginning to be acquired when a decision was made to abandon that site due to access problems and other issues. Attention was then turned to a site between Sterling and Chantilly, which was ultimately approved. It was ironic that Brother Rube, who had yearned to get away from the hustle and bustle of National Airport, would now have a 10,000-acre jet airport located on his mail route.

Simultaneously with all this happening, I was an employee of American Airlines at National Airport with an eye toward transferring to the new airport called Dulles when it opened. Of course, my desire to relocate to Dulles was enhanced by the fact that Rube and his family lived in Sterling.

My family and I purchased our first home and moved into Broad Run Farms in March 1960 with two young sons and another due in October. I immediately went to work with neighbors to help find a place for our children to play baseball, which ultimately led to the formation of the Lower Loudoun Little League. After that, we joined together to find a place of worship; I was a founding member of Potomac Baptist Church—known as the "church in the barn"—just across Route 7 from what is now Countryside.

Dulles Airport was dedicated on November 17, 1962, by Pres. John Kennedy. Pres. Dwight Eisenhower was also present, since the airport was being named for his secretary of state, John Foster Dulles. It was my honor to be in attendance, and I officially relocated to Dulles to work in March 1963.

With the establishment of Dulles along the Loudoun-Fairfax line, the die was cast for explosive growth to occur in the area. Many believed that the necessary infrastructure, including roads and schools, were woefully inadequate to handle the rapid development that transpired beginning in earnest with the development of Sterling Park in 1963. After a Loudoun School Board decision to locate the new Broad Run High School in a cornfield in Ashburn was made, I decided to seek the Broad Run District supervisor seat in 1967 and won in a landslide. So I segued from American Airlines passenger service into Loudoun County public service.

From 1968 to 1971, our board made some major decisions, including the establishment and location of a county sanitary landfill for the first time. Additionally, the board adopted a comprehensive plan to address the rapid growth happening right at our doorsteps. At the time, Route 28 was a two-lane gridlocked road at the front door of Dulles. Therefore, legislation was developed to create a "Transportation Tax District," which generated enough revenue from the commercial and industrial property owners to construct a multi-lane highway with some 12 interchanges from Route 7 to Interstate 66. Work simultaneously began to extend the Washington Metro service out to Dulles and beyond. I kept a campaign promise by sponsoring a successful budget amendment to provide a system of free textbooks in our public schools, and schools were built across Eastern Loudoun with a middle school and three elementary schools in Sterling Park alone.

In 1971, I decided to run for the state senate in a district that included all of Loudoun and Western Fairfax County to the beltway. I was fortunate to win by sheer hard work in a campaign I labeled "friendship and shoe leather," with much support from my Sterling friends and neighbors. While those struggling days of Sterling's yesteryear are now history, the transitions throughout have been captured in this book chronicling the story of my beloved hometown.

—Former Virginia senator Charles L. Waddell

ACKNOWLEDGEMENTS

Community is the first word that comes to mind when I think of Sterling, and that has been the common thread woven throughout that has brought this book to fruition. Capturing Sterling's tight-knit history came together through many hours of conversations—in person, by phone, and email exchanges included—and none of this would have been possible without the compassion of those who helped contribute to this book. It is thanks to Sterling's numerous residents, community members, and fellow history enthusiasts that this book has been made possible. I could not have done this without all of you.

My immense gratitude and thanks go out to the Crosen family (Cathy Crosen Kennan, James Crosen, Larry Crosen, and Linda Lawson), Joan Smith, Linda McCarthy, Philip Rosenthal, Marvin Miller, Marcia DeLong, Alicia Cohen, Julie and Amber Kerico, Paul McCray, the staff at Claude Moore Park (Sarah Massey, Gabriela Conrad-DiStasio, and Brian Danner), Susie Torres with Friends of Claude Moore Park, the Loudoun Heritage Farm Museum staff, Tracy Gillespie with Nova Parks, Christina Saull with Metropolitan Washington Airports Authority, Nick Wilt with Loudoun County Parks and Recreation, Monique Clark with Northern Virginia Community College (NVCC), Larry Roeder with the Edwin Washington Project, Laura Christiansen and Norah Schneider with Thomas Balch Library, Lori Wysong with Loudoun Museum, Don Schleiden with Sterling Cemetery, Barbara Glakas with the Herndon Historical Society, and the many contributors via Sterling Facebook groups. I also wish to thank my title manager at Arcadia Publishing, Caroline Vickerson. Special thanks go to Ira Kantor, consummate writing mentor and honorary editor; my parents, Steve and Kat, who aided me in many a field trip, image-sourcing, and fact-finding venture; and my constant support and motivator, Carlos.

A final note is necessary regarding this book's dedicatees, all of whom are no longer with us but were vital in shaping this project. George Barton served countless students during his years teaching at Park View High School and Northern Virginia Community College. I am a writer today thanks directly to his mentorship and guidance. Danny Ford, a beloved longtime resident, was fondly known as Sterling's unofficial historian. A large portion of the pictures and information in this book comes directly from his extensive archives. Lastly, Virginia senator Charles Waddell passed away prior to this book's publication, but it should be noted that he was vital to its publication and was one of the earliest champions of this project—I am forever grateful to him for contributing numerous hours of oral history, access to his personal photo archives, and writing this book's foreword.

INTRODUCTION

"What part of Sterling are you from? Old Sterling or new Sterling?" For those not familiar with Sterling and the surrounding area, these questions might seem perplexing. Neighborhood boundary lines are typically straightforward, but those with longer ties to the community know that Sterling's history is just a bit more complex.

Sterling is often referenced a variety of ways depending on who you're talking to: "Sterling Park" encompasses a primary portion of former farmland bought up and developed as "the first planned community East of the Mississippi" in the mid-1900s; "Old Sterling" references the area around Ruritan Circle where Guilford Station hosted a stop on the Washington & Old Dominion Railroad (W&OD) and various emporiums and saloons operated; and, in more recent history, newer neighborhoods in Countryside, Cascades, Sugarland Run, and Dulles subdivisions are also considered part of Sterling's borders.

Statistically speaking, Sterling has never been incorporated as a town or city. Rather, it is considered a census-designated place—an unincorporated community that does not have a legally defined boundary or active governmental structure. Because of this, Sterling's specific boundary lines can sometimes get a bit blurry. Regardless of which pocket of Sterling you consider yourself part of, the area as a whole encapsulates a rich history and represents a vibrant community that has experienced a series of evolutions since before its official inception.

This book aims to showcase, as thoroughly as possible, the highlights of Sterling's varied history. References to Sterling's newer subdivisions are included, though this history focuses on Sterling Park and the core of Old Sterling, where the community first established its roots and evolved largely through community-building and volunteer efforts. The information included here spans as early as the 1600s and continues through to the present day with chapters focusing on Sterling and Loudoun County's earliest-documented history; Sterling's dominance as a farming powerhouse into the mid-1900s; the significant African American farming communities in Sterling; the eventual shift to suburban housing and how its growth was accelerated, in part, by the creation of Washington Dulles International Airport; and finally, a reflection on the diverse community that Sterling represents today.

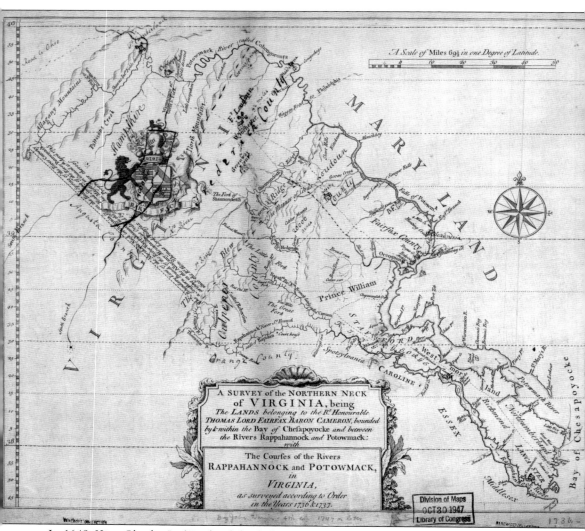

In 1649, King Charles I of England deeded five million acres of land between the Rappahannock and Potomac Rivers, known as the Northern Neck, to seven English noblemen. Pictured is one of the earliest official surveys, undertaken in 1736, of the land encompassing what is referred to as the Fairfax Proprietary (or Fairfax Grant). Between 1653 and 1730, Westmoreland, Stafford, and Prince William Counties were formed within the Proprietary, and in 1742, the remaining land was designated as Fairfax County. In response to growth in the area, the northwestern portion of Fairfax County became established as Loudoun County in 1757 by an act of the Virginia House of Burgesses. (Courtesy of the Library of Congress.)

One

EARLY LOUDOUN COUNTY AND STERLING
THE 1600s TO THE MID-1800s

In looking at the earliest recorded history of the area that eventually became known as Sterling, Virginia, it is useful to look first at the larger geographic profile of Loudoun County. While Loudoun County was not officially established until the mid-18th century, in the early 1600s, the area consisted of uncharted wilderness inhabited by Sioux (Manahoac), Algonquin, Iroquois, Susquehannock, and Piscataway Indians.

The area's Native Americans farmed, hunted, fished, and even occasionally traded with White trappers along the Potomac River. The river, an integral trading watershed, derived its name from an American Indian village, Patawomeke, though its name origin has also long been debated as meaning either "river of swans" or "river of traveling traders."

In subsequent years, various land grants and inheritances began to encroach on the Native American lands. By 1722, the Treaty of Albany, signed by leaders of the Five Nations of Iroquois, established the Blue Ridge Mountains as a buffer between Indian territory out west and White settlements in the east. It essentially forced the Iroquois and tributary Indians to move west of the Blue Ridge Mountains. From here, the presence of American Indians in present-day Loudoun ceased.

By 1725, settlers from Pennsylvania, New Jersey, and Maryland had already begun flocking to the area, and by 1749, approximately 2,200 people from multiple groups (including English, German, Scotch-Irish, and more than 600 African-born and Creole slaves) populated what would become Loudoun County. As the area grew, so too did the need to formally recognize the region: Loudoun County was officially established in 1757.

By the mid-1750s, the earliest Sterling-specific history can be traced to Vestal's Gap Road and Lanesville Historic District, a route that runs from the port of Alexandria to present-day Leesburg and on to Winchester. A portion of the road runs through modern-day Sterling, and archaeologists believe the road originated as a series of hunting paths used by Algonkian-speaking native tribes before the first settlers arrived in the area. A timeline of Vestal's Gap Road, produced by the Lanesville Heritage Preservation Society, notes, "There is good possibility that [American Indians]

camped next to the 'road.' Two perennial springs in close proximity to the road provided reliable water sources, plentiful quartz and quartzite available for tool-making."

One of the earliest recorded uses of the road dates back to 1692, when the Rangers of Pottomack, commanded by David Strahan, became the first known party of colonists to enter the future Loudoun County and utilized Vestal's Gap Road to monitor Indian activity, of which they found none. The road opened to colonists more broadly following the 1722 Treaty of Albany.

In 1753, Maj. George Washington, then 21 years old, traveled Vestal's Gap Road to deliver a letter from the governor of the colony of Virginia to the French military forts in southwestern Pennsylvania. He would travel the road again in 1754 with 120 militia men heading toward Fort Duquesne to confront the French. Washington was defeated at Fort Necessity, and this battle is considered as a prelude to the French and Indian War.

A year later, in 1755, during the French and Indian War, Washington served as a scout for 2,100 British and American troops. Vestal's Gap Road served as an important thoroughfare, and a portion of Gen. Edward Braddock's troops traveled the road west through Loudoun County to engage the French at Fort Duquesne. The mission was ultimately a disaster when they were ambushed by the French east of Pittsburgh—700 troops were killed, Washington was wounded, and General Braddock was killed.

The area of land today known as Claude Moore Park, which houses sections of the original Vestal's Gap Road, was formed from portions of two grants bestowed by Lord Fairfax in 1729—one grant had been made to Robert Carter Jr. (son of the famous "King Carter" of colonial Virginia) and the other to Elizabeth and Frances Barnes. The Barneses' land became known as "the Sisters Tract." The land was more formally developed in 1779 when it was conveyed to William Lane. A two-story house and separate kitchen were built on the site, and in 1781, William and his wife, Sarah Lane, welcomed daughter, Ann Carr Lane, who was born in Lanesville House, situated on the family's 1,000-acre homestead. The house underwent many improvements and additions throughout the years.

According to *History of the Lanesville Heritage Area*, William sold the land to his brother, Hardage Lane, in 1800. Hardage's daughter, Keturah Lane, continued to live in the house after her father's death in 1803. Keturah and her first husband, John Keene, went on to open a post office and tavern out of the house. After John's death in 1814, Keturah married Benjamin Bridges three years later. In 1847, their son, also named Hardage, acquired land from the former Robert Carter Jr. grant and joined it to the Sisters Tract. After Hardage died in the Civil War, land records were lost, spurring land suits lasting many years. It was not until around the turn of the century that the present park lands were legally consolidated into a single parcel.

In 1870, Bridges' Schoolhouse was built on the Lanesville property, and it is considered the oldest existing schoolhouse in eastern Loudoun County. While the building could accommodate up to 25 children, its overall expense meant that there would have been one set of books for the entire class to use and a variety of ages were taught by the same teacher. The range in ages made lesson planning difficult, requiring a new level of ingenuity—for example, arithmetic problems were made to accommodate the age of the children and included real-world calculations pertaining to agriculture given that many of the children lived on nearby farms. At Bridges' School, there was also an upstairs bedroom and sitting room where the teacher, Benjamin Bridges II, lived. It has undergone extensive preservation efforts in recent years and serves as a unique firsthand example of what education looked like during the later 1800s.

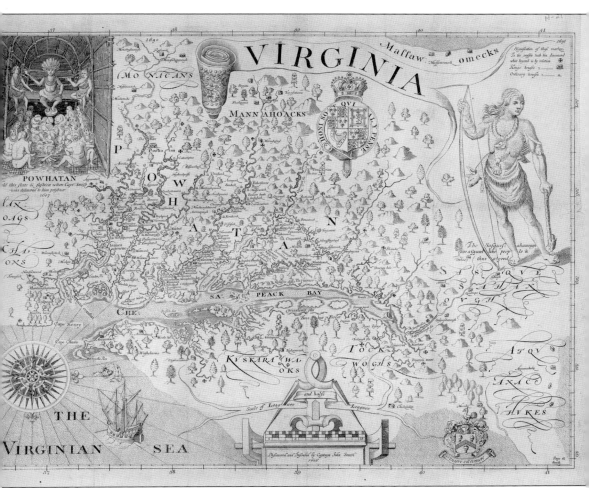

Starting in 1607, Capt. John Smith set about exploring the Chesapeake. In the first detailed map of the region, created by Smith in 1612, geographic landmarks of the area are outlined as well as numerous Indian towns. The Sioux were the most populous and occupied the largest area. On Smith's map, there are four Sioux villages shown at the dawn of Virginia's history, along the Rappahannock and Rapidan Rivers. (Courtesy of the Library of Virginia.)

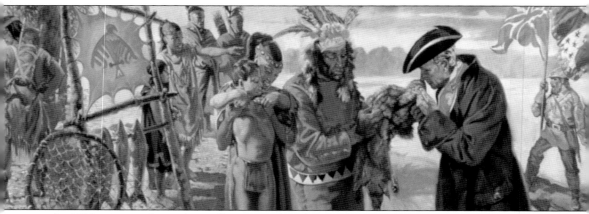

In 2003, renowned muralist William Woodward created a four-part frieze that was installed at the Thomas Balch Library in Leesburg, Virginia. Here, a section of the panel depicts the first recorded meeting on April 12, 1699, between colonists and the Piscataway. The meeting included the first settlers to explore the interior of Loudoun County, Burr Harrison and Giles Vandercastel, who conveyed a request from then Virginia governor Francis Nicholson to the chief of the Piscataway to come to Williamsburg for a meeting. The Piscataway declined, asking the governor to visit them. (Courtesy of Thomas Balch Library.)

The Commonwealth of Virginia frequently disputed the boundaries of the Northern Neck, and it was not until 1745 that the land was formally consolidated under one man—Thomas, Lord Fairfax, a Scottish peer and trader—via London's Privy Council. His namesake, Fairfax County, was formed in 1742 from the northern part of the earlier established Prince William County. (Courtesy of the Library of Congress.)

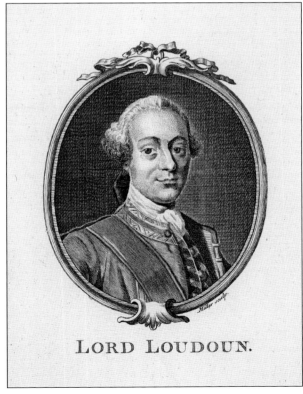

LORD LOUDOUN.

In response to growth in the area, the northwestern two-thirds of Fairfax County became established as Loudoun County in 1757 by an act of the Virginia House of Burgesses. The county was named for Scottish nobleman and army officer John Campbell, Fourth Earl of Loudoun (a parish in East Ayrshire, Scotland). He served as governor-general of Virginia from 1756 to 1759 but never actually set foot in his namesake Loudoun County. (Courtesy of the Scottish National Portrait Gallery.)

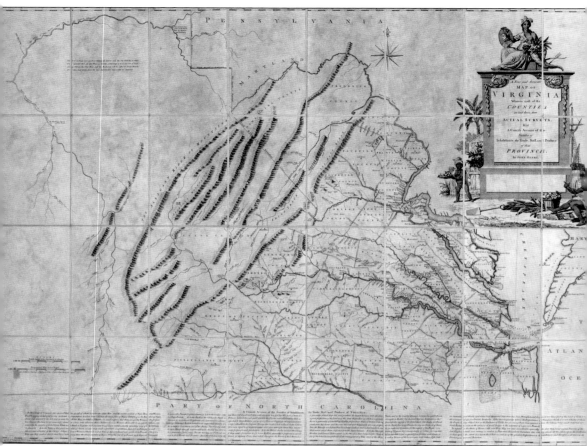

John Henry's 1770 map of Virginia was the first attempt to show the boundaries of counties via actual surveys of the land, though Sterling was not yet listed. The map also attempted to reflect a concise account of the number of inhabitants, in addition to the trade, soil, and produce of Virginia. The footnotes of the map noted the colony as "much the richest as well as of the greatest importance to Great Britain and therefore well deserves its encouragement and protection." (Courtesy of the Library of Congress.)

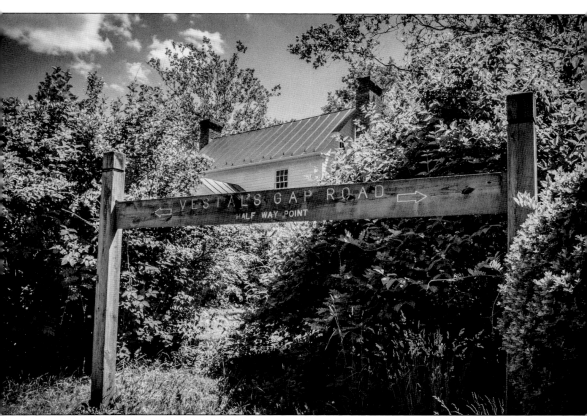

Vestal's Gap Road remains among the oldest remaining segments of colonial pathway in America. Its historic value, and George Washington's repeated use of the road, was summarized by historian Fairfax Harrison in *Landmarks of the Old Prince William*: "This road early played a part in American History . . . and yet it might with more propriety be called the 'Washington Road,' for the father of this country used it frequently; conspicuously in public service of his expeditions to Fort Duquesne in 1753 and again the following year when he marched in command of the Virginia regiment." Washington also documented his trips along Vestal's Gap Road in his journals, which underscores the important role the road played in the French and Indian War. There certainly would have been busy days along the colonial pathway as soldiers, cannons, and support units traveled through. Today, visitors to Claude Moore Park in Sterling, where a portion of the road has been preserved, can still trace Washington's footsteps from that period. (Courtesy of C.E. Couchman.)

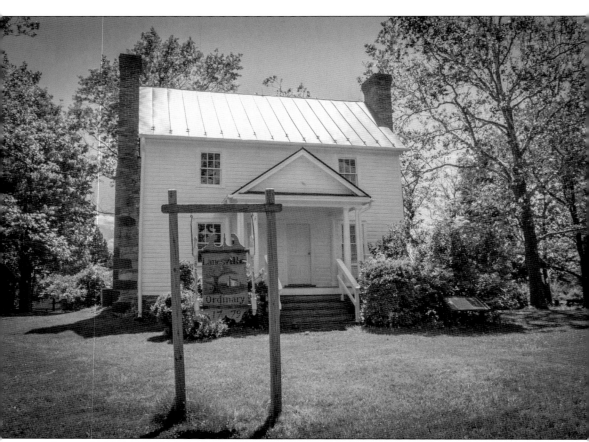

Situated off of Vestal's Gap Road is Lanesville. The earliest mention of the Lanesville home exists on an 1807 Loudoun County application submitted by John Keene to run an "ordinary," a rest house and overnight tavern for travelers. That same year, the Lanesville Ordinary and Post Office were opened in the Lanesville House. Both continued to operate into the 1820s. The site served as an important social gathering spot for both travelers and local families. In the aftermath of British troops burning down Washington, DC, during the War of 1812, the Declaration of Independence, the Constitution, and other crucial historical documents were brought to Leesburg via Vestal's Gap Road for safekeeping in 1814. However, by 1825, when Leesburg Turnpike was opened all the way to Leesburg, most through traffic was no longer utilizing Vestal's Gap Road. The Lanesville Heritage Preservation Society notes, "Travel had changed to horse and buggy rather than ox cart, people were able to travel farther distances between rest stops, and this resulted in less business for ordinaries." (Courtesy of C.E. Couchman.)

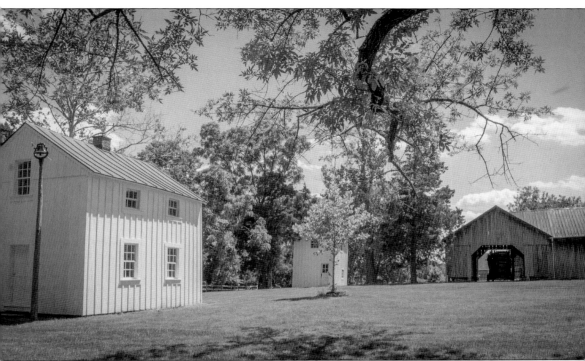

Benjamin Bridges II, a schoolteacher and Loudoun justice of the peace, built the two-story, one-room coed schoolhouse around 1870 and operated the school at Lanesville, pictured at far left. In *History of Secondary Education in Loudoun County, Virginia*, records indicate that the school operated until 1875. While education in the area had previously been a largely private endeavor, the Bridges' School served residents at large when the public school system in Loudoun County was formally established in 1870. (Courtesy of C.E. Couchman.)

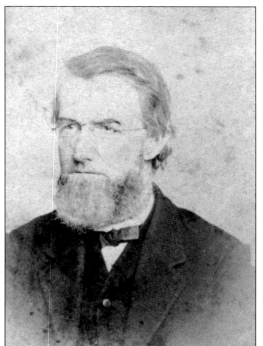

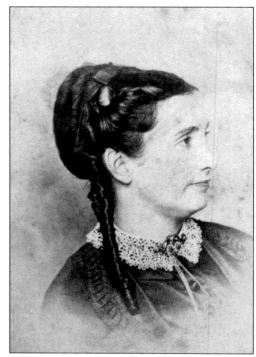

In 1853, Benjamin Bridges II (pictured above left) married Lucy Alice Elgin (pictured above right), and the pair raised their five children—Dorsey, Molly, Frank, Benjamin III, and Irene—at Lanesville House. Benjamin Bridges II died in 1900. Irene Bridges (pictured below left) never married and purchased the property in 1905 after her mother's death in 1904. In 1941, she placed the Lanesville House and surrounding property up for auction. (All, courtesy of Claude Moore Park archives.)

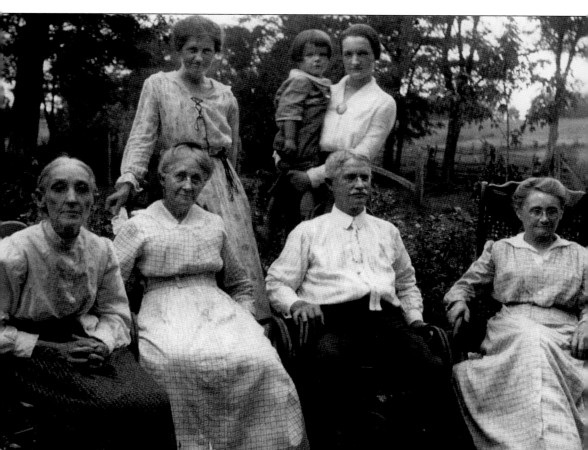

The Lane family continued to own the property that housed the Sterling tract of Vestal's Gap for 162 years. The Lanesville House, along with the historic school and other outbuildings, remain at Claude Moore Park. The Lanesville Workhorse Museum is also housed on the property, and early farming implements can be found throughout the park. Pictured in the first row from left to right are Annie Miskell, Alice Bridges, Benjamin Bridges III, and Irene Bridges. Irene would be the last of four generations of the Lane family to live in the Lanesville House. The woman pictured at the top left is unidentified, and at the top right is Bertha Bridges Nelson holding her daughter Ann. (Courtesy of Claude Moore Park archives.)

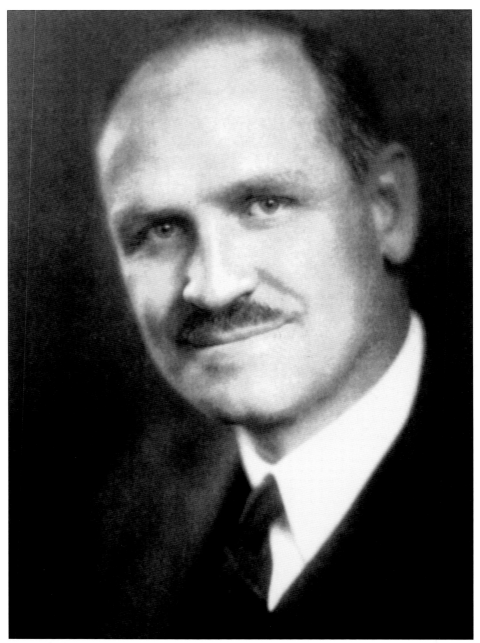

In 1941, radiologist Dr. Claude Moore purchased the Lanesville property at public auction at approximately $40 per acre for upwards of 400 acres. Dr. Moore possessed the property until 1975, when he donated it to the National Wildlife Federation for environmental education outreach. He did, however, retain the estate and continued to reside in Lanesville until his death in 1991, just shy of his 99th birthday. It is rare that a property with such history was home to only two families during the 213 years it was occupied, and Dr. Moore's desire that the land and historic buildings be preserved was key to the existence of the park as it exists today. (Courtesy of Claude Moore Park archives.)

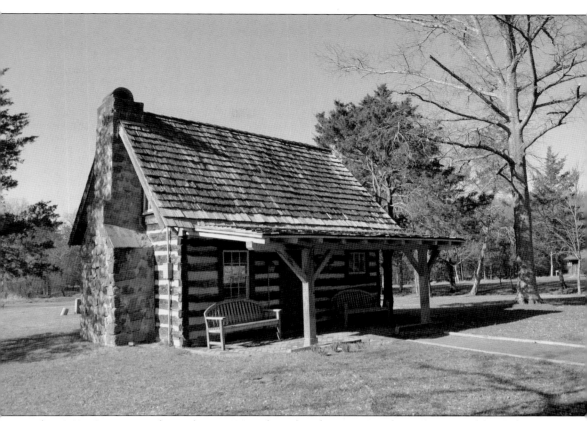

In the 1960s, Dr. Moore relocated an 1860s-era log cabin that once stood on a farm in Ashburn that he owned to Claude Moore Park. It was dubbed "Frogshackle Cabin" and now serves the park as a nature center. Dr. Moore was described by many who knew him as eccentric and independent—in an interview when he was 93, Moore told of how he built the cabin's attached fireplace sometime in the late 1970s by hand, by himself, when he was in his 80s. (Courtesy of Steve DeLong.)

The earliest Loudoun County Court seal known to date was discovered in 2016 when staff members in the Clerk of the Circuit Court's Historic Records Division discovered an 1833 seal on the freedom certificate of former slave James Wood, uncovered as part of the court's Free Blacks and Slave Papers. At the time, former slaves who were adjudicated by the court to be free, after completion of legal paperwork as evidence of a slave owner's wishes to release a slave, were required to have freedom certificates. (Courtesy of Gary M. Clemens, Clerk of the Circuit Court, Historic Records Division.)

Two

Civil War Years and Agricultural Beginning

The Mid-1800s to the Early 1900s

Loudoun County continued to populate into the 1800s, and the same trend applied to the area that eventually became the Sterling of today. Farming and agriculture were the area's primary industries and remained so in Sterling up through the better part of the 20th century.

Newton Keene, son of John and Keturah Keene of Lanesville House, and his wife, Elizabeth (née Dulin), are noted as owning one of the earliest recorded farms in the area. In 1829, they purchased 197 acres south of what today is Church Road and established Green Plains Farm, where they would raise 13 children. Eventually, the farm was inherited by their daughter Sarah Frances Keene, who married Samuel Edwin Edwards, a justice of the peace and respected community member. The Robert Edwards Collection at Thomas Balch Library details how Edwards proved instrumental in developing Green Plains Farm into one of the most prosperous dairy farms in Northern Virginia, becoming an early member of the Maryland & Virginia Milk Producers Cooperative.

Another early recorded business was Sterling Farm, a cattle and dairy business purchased in 1909 by journalist and academic Dr. Albert Shaw. The land originally contained 1,640 acres and was dubbed "the Experimental Farm," as Shaw was the first farmer in the area to receive a federal grant for applying scientific methods to the raising of crops and livestock. In 1938, Shaw gifted the farm to his son Albert Shaw Jr. The farm was later purchased from the younger Shaw by its manager, Fred F. Tavenner. Tavenner went on to also buy nearby Robey Farm.

While Loudoun County's larger agricultural economy had been based primarily on grain crops in the 1800s, as Washington, DC, expanded during the early 1900s, the demand for milk and dairy products grew with it as well. In response, farms in Loudoun and nearby counties began to specialize in dairy farming.

At the same time that agriculture was flourishing in Sterling, the area was also establishing itself as a transportation hub that encompassed its own railroad station and commercial center for farmers. At the time, the area was not yet known as Sterling but rather as Guilford Station. In 1855, the Alexandria, Loudoun & Hampshire Railroad began construction of the first 40 miles of

the route from Alexandria to the coalfields of Virginia (later West Virginia). The Guilford Station stop was reached by September 9, 1859.

Records indicate that Pres. James Buchanan rode to Sterling by coach to escape the heat of Washington in the summers of 1859 and 1860, staying at a two-story residence dubbed "the Summer White House." Built in the 1850s, the building was located next door to the Sterling Mercantile accessed by Railroad Avenue, now known as Ruritan Road. The house operated for many years afterward as a hotel and antique shop before it was demolished in the 1980s.

It was shortly after its inauguration that Guilford Station began being used as a signal station during the Civil War. On June 19, 1863, up to 15,000 Union troops, commanded by Gen. John Fullerton Reynolds, marched along the Alexandria, Loudoun & Hampshire Railroad from Herndon to Guilford Station. Reynolds made his headquarters at Lanesville House, along Vestal's Gap Road, and ran a telegraph wire to Fairfax Court House.

According to A Citizen's Guide to Loudoun and the Civil War, assembled by the Civil War Sesquicentennial Committee of Loudoun, "Loudoun was right in the heart of the war for much of it. There were battles as well as guerilla warfare here, the famous armies marched right through, and much of the county was literally burned."

After abolitionist John Brown's ill-fated raid at Harpers Ferry in neighboring Jefferson County on October 16, 1859, panic raced through Loudoun County, even in areas with antislavery sympathies, since the raid threatened the safety of a racially controlled social order. After the raid, men around Leesburg formed the Loudoun Guard as a volunteer militia. Eventually, in response, Unionists formed the Loudoun Rangers.

On February 22, 1864, the Civil War arrived at the front door of Samuel and Henrietta Ankers at their home in Sterling, located at what is today the site of the Loudoun Campus of Northern Virginia Community College. Nearly 160 of Confederate lieutenant colonel John Singleton Mosby's horsemen ambushed Union captain James Sewall Reed's 150 cavalrymen after hiding in a pine thicket south of Dranesville Turnpike (present-day Route 7), below the ridge of Bridges Hill near Ankers's blacksmith shop. As Captain Reed's men rode by, Mosby sprang his trap and charged into the road, confusing Reed's rank. While Reed's men tried to rally, the Second Dranesville Battle ultimately resulted in Captain Reed's death, 12 other Union soldier deaths, one Confederate soldier death, 25 wounded, and more than 50 captured. The remaining soldiers in the skirmish fled to the nearby Potomac River.

Throughout the conflict, the county dealt with constant civil war amongst its residents, with some of the deadliest battles taking place in towns nearby to Sterling. This included the first large engagement of the war at the Battle of First Manassas in July 1861 as well as the Battle of Ball's Bluff in October of that year. Confederate general Robert E. Lee's surrender at the Battle of Appomattox Court House on April 9, 1865, would ultimately trigger the wave of other surrenders by Confederate forces.

Apart from the war, Sterling remained an agricultural-focused community with an intimate population into the 1900s. Historian Eugene Scheel writes that, at the time, residents of larger neighboring cities such as Leesburg, the county seat of Loudoun County, referred to trips out to Sterling as "goin' down the country." Within a couple of decades, this changed, and Sterling's overall landscape experienced a tremendous shift.

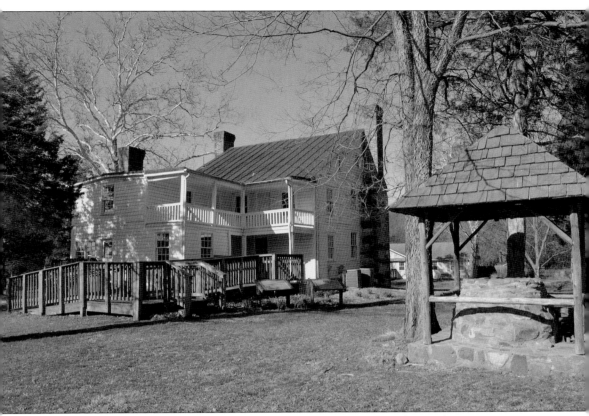

In 1863, at the height of the Civil War, a signal station was erected on the northwestern portion of the property at Lanesville House at 442 feet—one of the highest points between Washington, DC, and Leesburg. The signal station officer here constantly communicated with nearby signal stations attempting to locate Confederate general Robert E. Lee's Army of Northern Virginia. (Courtesy of Steve DeLong.)

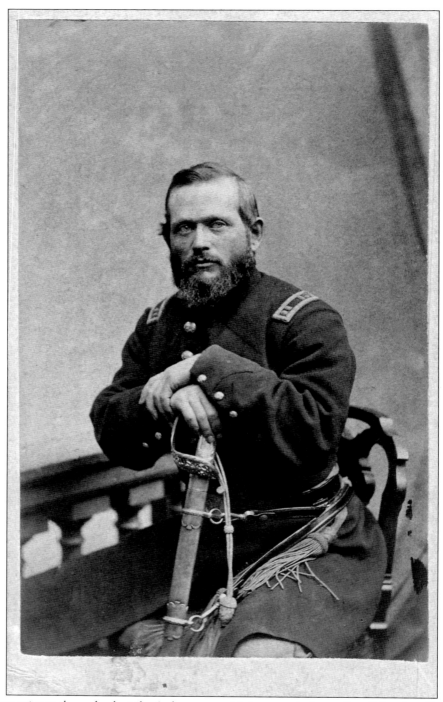

Two days prior to the ambush at the Ankers estate, Union captain James Sewall Reed and his men, composed primarily of the 16th New York Cavalry and Californians in the 2nd Massachusetts Cavalry, rode from Vienna west through Middleburg and Rector's Crossroads hunting unsuccessfully for Confederate lieutenant colonel John Singleton Mosby. (Courtesy of Michael Sorenson.)

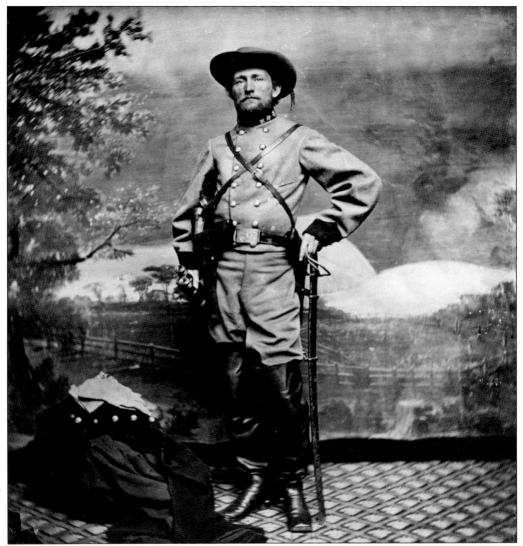

While attending a funeral a couple of days earlier, Lieutenant Colonel Mosby formulated his plan of attack for the Second Dranesville Battle after learning of the Federalist raid led by Captain Reed, dispatched by Union major Charles Russell Lowell. After the battle, some of the dead were buried in the Ankers family cemetery, and some of the wounded were tended to in the house. Later, approximately 35 of the captured Union soldiers died of illness or disease at the infamous prison camp at Andersonville, Georgia. (Courtesy of the Library of Congress.)

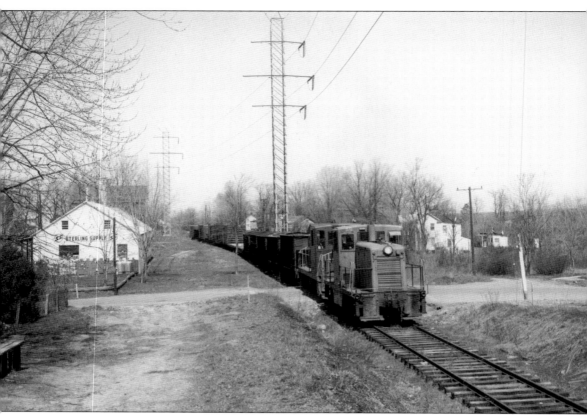

By 1883, J.P. Morgan had purchased the Alexandria, Loudoun & Hampshire Railroad line, and this eventually became part of what is now known as the Washington & Old Dominion Trail, the paved trail that follows the route along the former roadbed of the Washington & Old Dominion Railroad. The station served local farmers, and trains carried grain, produce, and dairy products to markets, returning with merchandise and mail. Passengers included students riding to school or those commuting to jobs in Washington, DC. By the time the above picture was taken in 1967, Sterling had grown from a stop on the railroad to a large residential development. The white building to the left of the train housed the Sterling Supply Store. Today, there is a historical marker along the trail noting where the location of Guilford Station once stood. (Courtesy of Nova Parks.)

WASHINGTON AND OLD DOMINION RAILROAD

Time Table No. A-10

Effective 12.01 A.M. (Eastern War Time) Monday, January 31, 1944

(Cancels Time Table No. A-9)

For the Government of Employees Only

DAILY EXCEPT SUNDAYS

G. C. BAGGETT Vice-President and General Manager	BETWEEN ROSSLYN AND PURCELLVILLE	J. M. McLANEY Chief Dispatcher

WESTBOUND TRAINS (First Class)			Miles from Rosslyn	STATIONS	Station Numbers	EASTBOUND TRAINS (First Class)			Minimum Time bet. Stations Frt. Trains
3	5	1				2	4	8	
P.M.	P.M.	A.M.		Lv. Ar.		A.M.	A.M.	P.M.	
6.05	1.55	6.15	.0	Rosslyn	1	7.40	11.05	7.24	
			1.5						7
f6.10	f2.01	f6.20	1.5	Thrifton	2	f7.35	f10.59	f7.18	
			3.0						13
f6.23	f2.11	f6.28	4.5	Bluemont Jct.	5	f7.22	f10.50	f7.09	
			2.0						7
f6.28	f2.16	f6.35	6.5	Falls Church	7	s7.17	s10.45	s7.04	
			1.2						4
f6.34	f2.22	f6.39	7.7	West End	8	f7.11	f10.40	f6.59	
			2.1						7
f6.39	f2.28	f6.45	9.8	Dunn Loring	10	f7.06	f10.34	f6.53	
			1.0						3
f6.42	f2.30	f6.47	10.8	Wedderburn	11	f7.02	f10.32	f6.51	
			1.6						5
s f6.46³	f2.37	s f6.56²	12.4	Vienna	13	s f6.56¹	f10.27	s f6.46³	
			2.9						9
f6.54	f2.45	s7.05	15.3	Hunter	16	s6.49	f10.19	f6.39	
			3.1						10
f7.03	f2.55	f7.13	18.4	Sunset Hills	18	f6.40	f10.09	f6.31	
			2.2						7
s7.10	f3.01	f7.20	20.6	Herndon	21	s6.35	s10.03	s6.25	
			3.5						11
f7.19	f3.11	f7.30	24.1	Sterling	25	f6.25	f9.54	f6.13	
			4.0						12
f7.30	s3.22	f7.39	28.1	Ashburn	29	f6.15	f9.42	f6.03	
			2.0						7
f7.35	f3.27	f7.44	30.1	Belmont Park	32	f6.10	f9.37	f5.58	
			4.6						14
7.45	s3.40	s7.58	34.7	Leesburg	35	6.00	s9.27	s5.48	
			3.7						11
P.M.	f3.52	f8.13	38.4	Clarkes Gap	39	A.M.	f9.12	f5.35	
			0.8						3
----	f3.55	f8.16	39.2	Paeonian Sps.	40	----	f9.10	f5.33	
			1.8						6
----	f4.00	f8.21	41.0	Hamilton	41	----	f9.04	f5.28	
			3.6						12
----	4.15⁸	8.32⁴	44.6	Purcellville	45	----	8.55¹	5.20	
P.M.	P.M.	A.M.		Ar. Lv.		A.M.	A.M.	P.M.	
3	5	1				2	4	8	

Guilford Station was renamed Loudoun Station in 1872 by the postmaster as it was the first stop over the Fairfax County/Loudoun County line. It was finally named Sterling Station in 1887 by J.P. Morgan himself. Some historians believe Sterling was named after Lord Loudoun's castle in Scotland. However, it is also hypothesized that Morgan or one of his directors chose the name Sterling because of Morgan's large banking interests, though the certainty of Sterling's naming origin is still up for debate. In this 1944 timetable, Sterling is listed as one of the key stations between Rosslyn and Purcellville. (Courtesy of Nova Parks.)

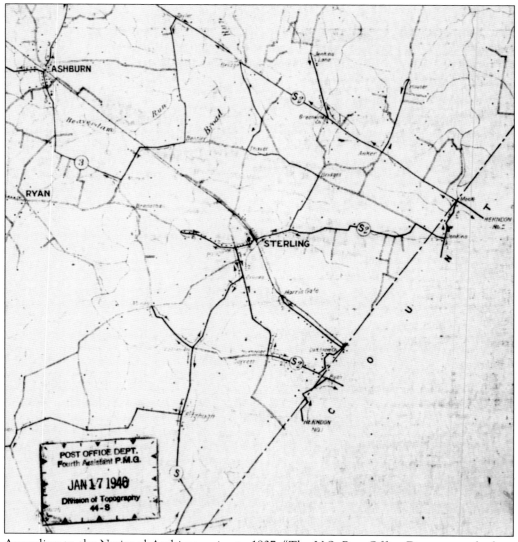

According to the National Archives, prior to 1837, "The U.S. Post Office Department had no official mapmaker and purchased its maps from commercial firms or private individuals. On March 13, 1837, Henry A. Burr was appointed the first Topographer of the Post Office, and he began preparing maps for postal officials' use." This 1946 report shows Sterling and its post office at the time in relation to other nearby post offices, transportation routes, and facilities. (Courtesy of the National Archives.)

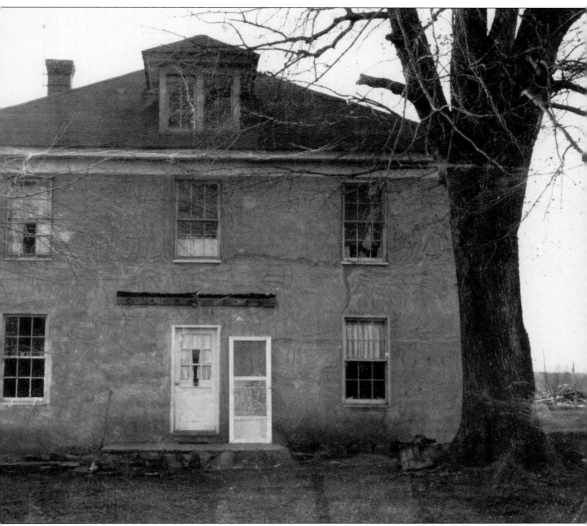

This photograph is one of the earliest known images of an original house that stood in Sterling prior to the 1960s building boom. The structure and 400 acres were purchased by Robert B. Moore Sr. in the early 1950s. His wife, Clara V. Moore, named the surrounding area Tall Oaks Subdivision. This designation remains to this day. Located on Sterling Road, the house was gifted to their oldest child, Josephine Moore McCarthy, and her husband, David W. McCarthy Sr., as a wedding present. Josephine and David's daughter, Linda McCarthy, dates the home's history back as early as 1917. (Courtesy of Linda McCarthy.)

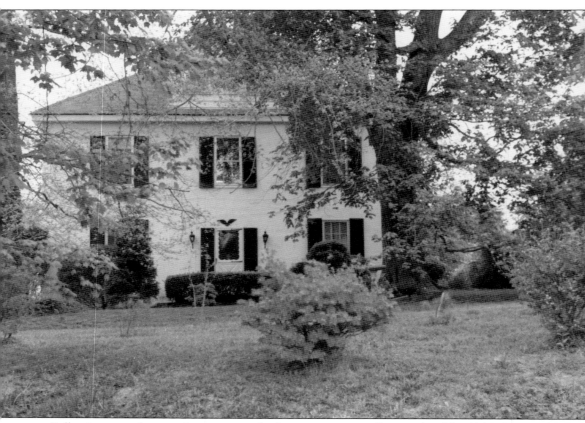

Following several years of renovation, the house was essentially completed by 1964. During the process, the family found piece-by-piece instructions written in chalk on individual rafters and beams from the original house construction. When it was first built, the materials for this prefabricated pattern house had been delivered by horse-drawn wagons to the site from the railroad stop at Guilford Station. (Courtesy of Linda McCarthy.)

A small, close-knit community grew up around the railroad station. Airy wooden homes lined the north side of the tracks. On the south side were several businesses including a mercantile store, a mill, and a meat market. This picture shows a home in Sterling from 1948. (Courtesy of Thomas Balch Library.)

Typical of Sterling at the time, the area around the McCarthy property was rural and remained that way into the late 1970s and early 1980s. Linda, Dave, and Bill McCarthy recall that, for a time, the first floor of the house started off as an earthen-floor shell—the area that would eventually become the living room housed both the family's bull and mischievous pony, Muffet, at different points. (Courtesy of Linda McCarthy.)

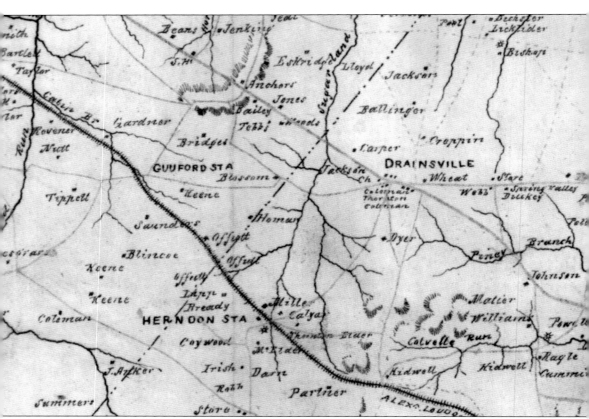

A section of the 1864 map by Paul Hoffmann and Samuel Howell Brown shows one of the earliest visual representations of Guilford Station. The map also details local landowners, including the nearby Keene family landholdings of Green Plains Farm. (Courtesy of the Library of Congress.)

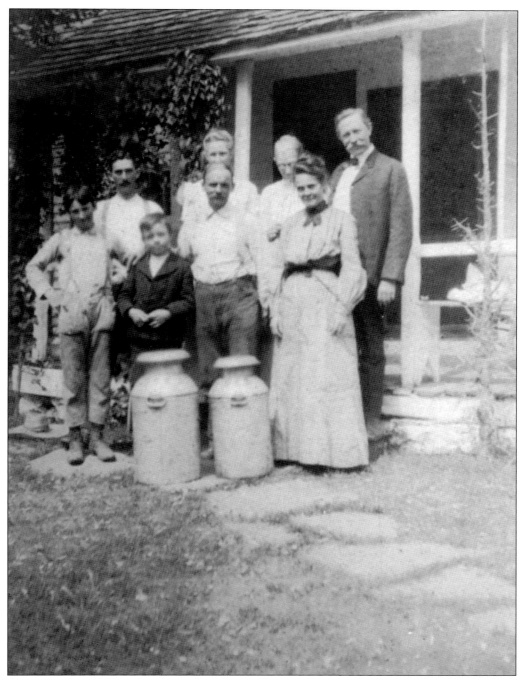

A group at Green Plains Farm stands in front of large milk cans. The barn on the property, built in 1930 by Samuel and Sarah's son Lee Edwin Edwards, still stands today as a landmark in Sterling Park and has been used for various purposes throughout the years. Today, it is home to the Loudoun Elks Lodge. (Courtesy of Loudoun Museum.)

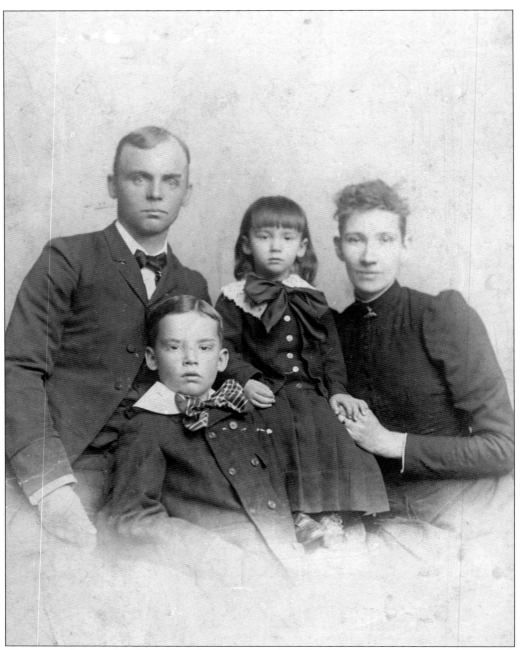

Above is a photograph of the Edwards family around 1890–1895. Their farm stayed in the family for many years as Samuel and Sarah's son Lee continued to both live in the home and operate the business. The 311-acre property was sold to developers in 1961, and the area was developed into what is today the Cascades neighborhood, comprising more than 6,500 homes in the planned community. Some of the family's farming implements are still on display in the Loudoun Museum in Leesburg. (Courtesy of Loudoun Museum.)

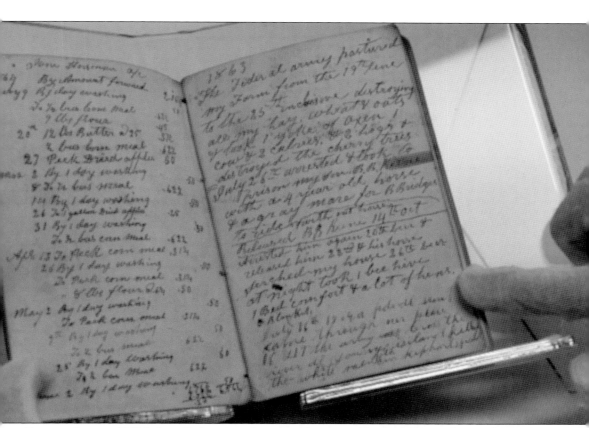

Excerpts from an 1863 ledger, likely written by either Newton or Elizabeth Keene, discuss the Civil War, stating, "The Federal army pastured my Farm from the 19th June to the 25th." The ledger goes on to state that various crops were destroyed by the army and that the couple's son, Benjamin Bridges, was arrested and released multiple times over the course of several months. (Courtesy of the Robert Edwards Collection, Thomas Balch Library.)

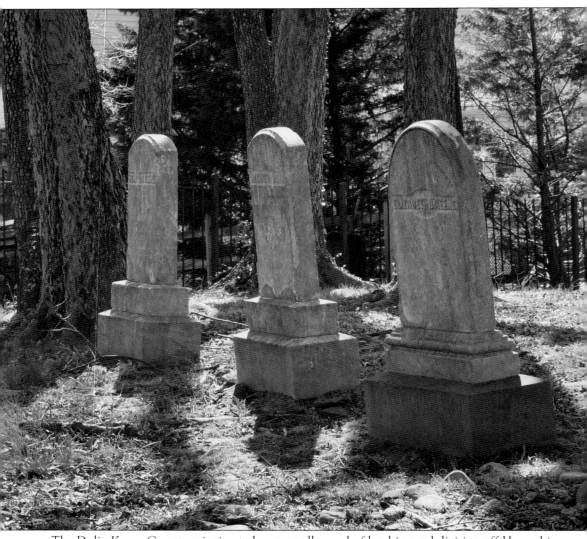

The Dulin-Keene Cemetery is situated on a small parcel of land in a subdivision off Hampshire Station Drive in Cascades and was protected during the time the subdivision was being built. Its primary gravestones include those of Elizabeth Dulin Keene (1806–1874), Newton Keene (1804–1880), and their daughter Elizabeth Keene Kinney (1834–1898). During the development of Cascades in the spring of 1989, a mystery arose when the three gravestones went missing. A family descendant had the stones moved for safekeeping until the construction of surrounding houses was completed. In 1992, all was righted when the gravestones returned to the site. There is evidence of several other unmarked graves at the cemetery. (Courtesy of Steve DeLong.)

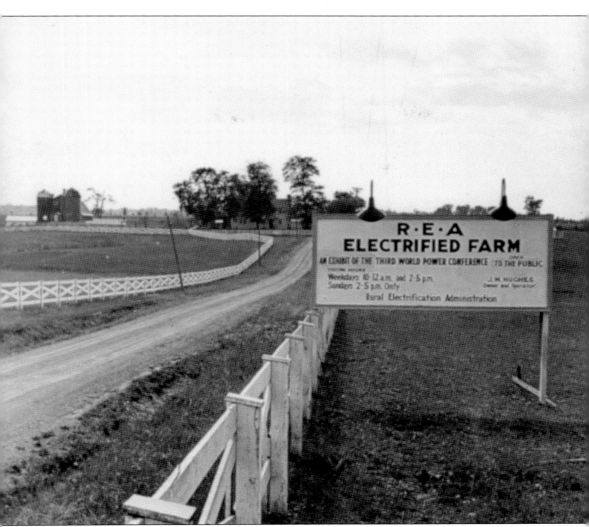

Jesse M. Hughes's dairy farm, located on Route 7, was the first electrified farm in Loudoun County and was a Rural Electrification Administration demonstration site in 1936. The farm was eventually sold in 1961 to housing developer M.T. Broyhill and Sons Corporation. The Sterling Park Development Corporation redeveloped the land to make way for Section 6-C of what would become Sterling Park. (Courtesy of the National Rural Utilities Cooperative Finance Corporation.)

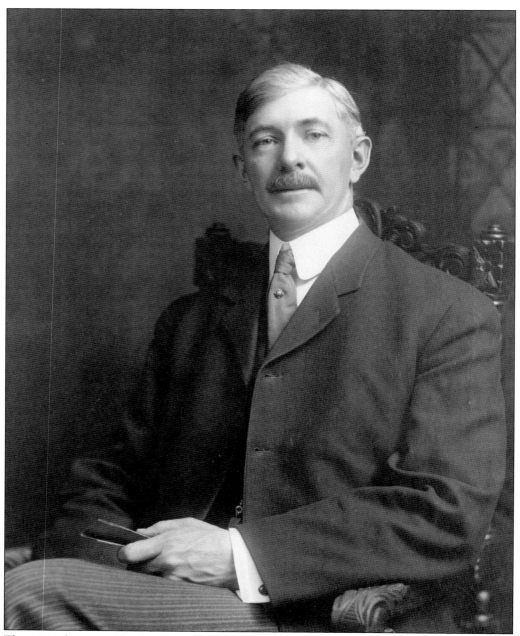

The original owner of Sterling Farm, Dr. Albert Shaw, wrote and spoke frequently on topics around the relationship of business and organized labor and agricultural reform, which carried over to how Sterling Farm was operated. (Courtesy of the Library of Congress.)

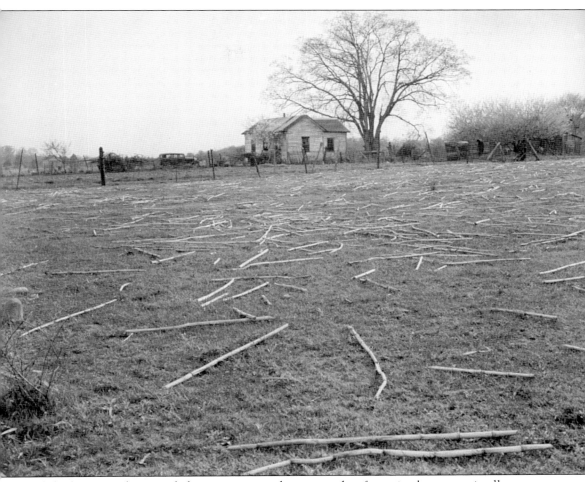

While dairy was the overwhelming major product sourced at farms in the area, miscellaneous other livestock such as poultry served as key income sources on Sterling farms. Here, cornstalks are thrown to livestock as winter forage and cover the open land of a Sterling farm around the 1930s. (Courtesy of the Library of Congress.)

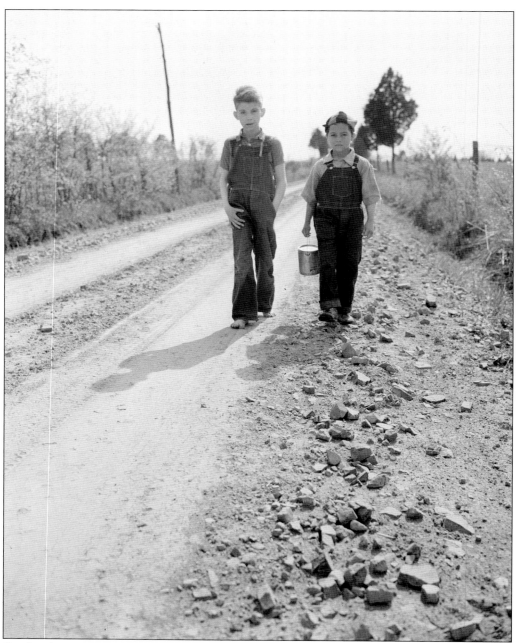

On October 11, 1879, the Broad Run School District No. 6 purchased a one-acre parcel of land in Sterling from Dr. James E. Warner at a discount price of $60 and built a two-room schoolhouse. The first public school in Sterling opened for spring term in 1880. The boys in this photograph, on their way to school in 1940, would have attended the original Sterling schoolhouse. (Courtesy of the Library of Congress.)

The school, shown in this 1940 photograph, had no running water or bathroom but two outhouses did exist in the backyard, one for boys and one for girls. The school served students until 1947, when a second schoolhouse was built on Church Road. Herbert Keene bought the property in 1947 for $3,100, and the building became a residence and remained so for more than 30 years. (Courtesy of the Edwin Washington Project.)

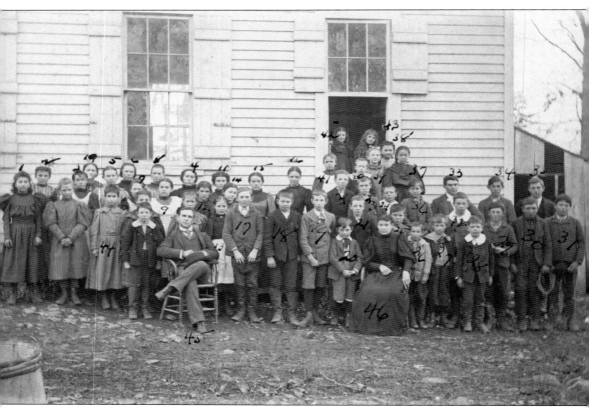

In the records of the Dulin and Keene families, one of the earliest photographs of the original Sterling schoolhouse shows students from the 1897 school year. Margaret Testerman, who taught at Sterling School in 1936 and 1937, recounted that during the early years, only one room was used for teaching, and the backroom was used for play and community activities. As Sterling was a farming community at the time, school operated for seven months of the year, as children were needed for spring planting and fall harvesting of crops. (Courtesy of the Robert Edwards Collection, Thomas Balch Library.)

Students at Sterling Elementary School gather for a class picture in 1926. Pictured in the first row seated center is Floyd Crosen, who went on to open Crosen's General Merchandise, one of Sterling's primary general stores, in 1947. Pictured at the center in the second row is the school's teacher, Pearl Hart. (Courtesy of the Crosen family archives.)

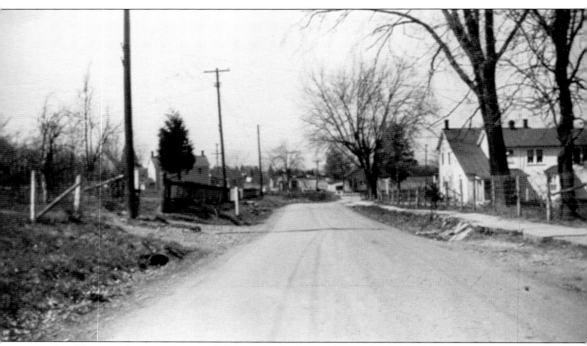

An *Observer News* article noted, "At one point in its history, Sterling had a total of five bars or saloons, Tavenners Wheelwright or blacksmith shop, run by George Ankers; a saddlery; Page's Grocery; and, in the Harvey Crosen house, a combination shoe store, bar and post office. In later years Floyd Crosen built a bigger house and store on Church Rd. closer to Route 28." The above picture shows a stretch of Route 625, or Church Road, when it was still a dirt road in the 1950s. (Courtesy of the Crosen family archives.)

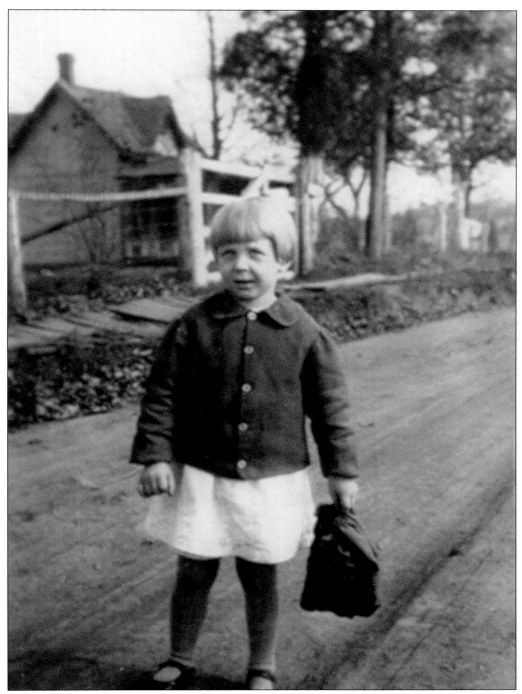

Parts of Sterling also featured wooden sidewalks, which can be seen behind the girl in the picture. It is believed this mid-1900s photograph was also taken near West Church Road, close to where the 1964-era Sterling Elementary School was eventually built. (Courtesy of the Crosen family archives.)

At the time that Floyd and Mary Crosen married in 1934, Sterling was a community of about 250. Before the end of World War II, the pair went on to purchase a lot on Church Road for between $700 and $800 and begin work building a store and home on the property. Crosen's General Merchandise opened for business on October 27, 1947. According to a 1987 *Loudoun Times-Mirror* article, "Many of their customers were neighboring farmers, so the Crosens sold hog, cattle, and chicken feed" along with yard goods, hardware, gas, and other grocery staples. (Courtesy of the Crosen family archives.)

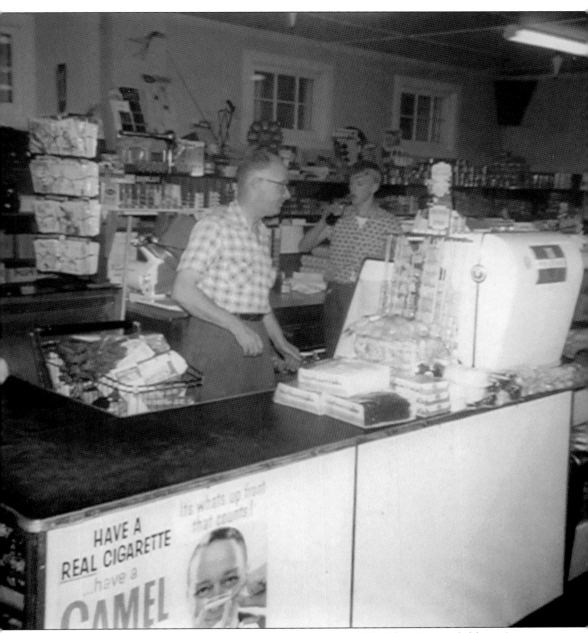

Floyd Crosen supervises the store with his son, Larry Crosen. All of the Crosen children—James, Donald, Larry, and Linda—grew up in the store and helped their parents run it by stocking shelves or delivering orders. James's daughter Cathy Crosen also recalls fond memories of the store and climbing feed bags in the warehouse behind the building as a child. (Courtesy of the Crosen family archives.)

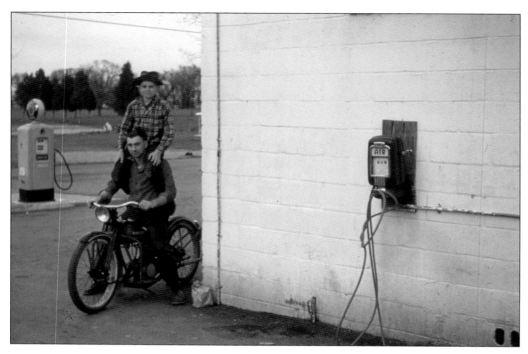

After more than two decades of operation, Crosen's General Merchandise, the last general store in Sterling, closed on October 30, 1969. Reflecting on his time growing up in Sterling in the 1940s and 1950s, Jimmy Crosen told the *Loudoun Times-Mirror*, "It was the best, absolutely." (Both, courtesy of the Crosen family archives.)

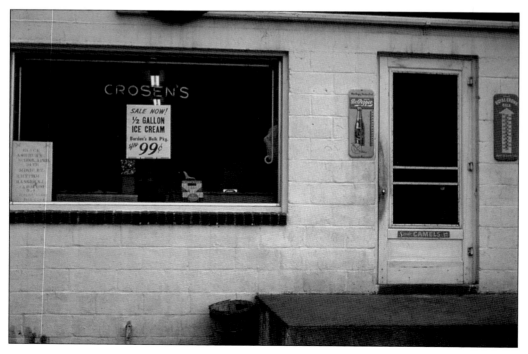

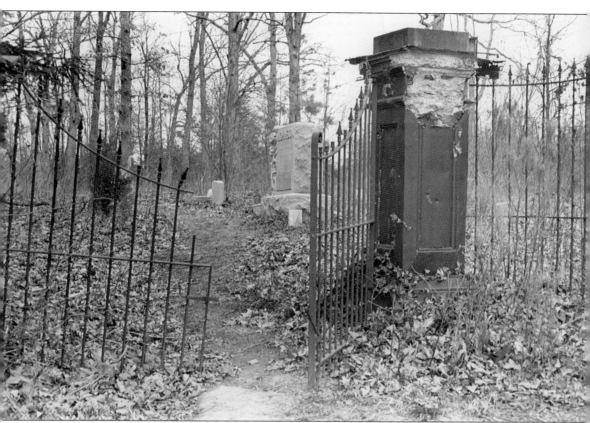

Sterling's original cemetery, located at the corner of West Church Road and Cascades Parkway, covers 2.2 acres and was deeded in 1892. According to records from former Sterling Cemetery trustee and president Peggy Testerman, James Emerson Warner had deeded land to trustees Levi Hanford, George Johnson, and Nelson Potter for the consideration of $30. The cemetery records at least 26 individuals interred, with the oldest tombstone burial dating back to 1870. Several generations of families are buried together here including the Ankerses, Hanfords, Johnsons, Lents, and Thayers. The newer 4.8-acre Sterling Cemetery was established in 1914 and is located just across the street from the original cemetery on West Church Road. William Stanley Brown, author, reporter, and original producer of CBS's *60 Minutes*, is buried at the newer Sterling Cemetery. (Courtesy of Sterling Cemetery.)

Bill Davison reigned as postmaster of Sterling until 1914, when Rose Newman took over and ran the post office out of her home, followed by Mildred Kidwell Smith, who took over in 1939 after Newman died. Smith had a cinder block post office built in 1945 that served until 1964, when a brick building at the southeast corner of Sully and Church Roads arose in its place. Elizabeth Page (left) and Mildred Smith (right), who served as postmistress for 40 years, pose outside one of the earlier iterations of the post office. In 1976, the post office was relocated to a modern facility next to the Sterling Park Shopping Mall off Sterling Boulevard. (Courtesy of the Crosen family archives.)

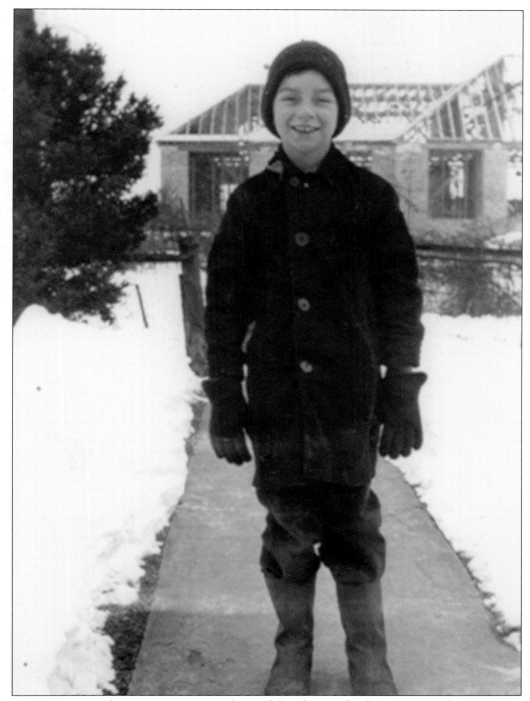

As the greater Sterling community grew, the need for a larger school arose. Here, Alton Tavenner Jr. poses in front of the future Sterling Elementary School as it is being constructed. The all-brick building served the community from 1946 through January 1964, when students were moved to the third Sterling Elementary at 200 West Church Road. (Courtesy of the Crosen family archives.)

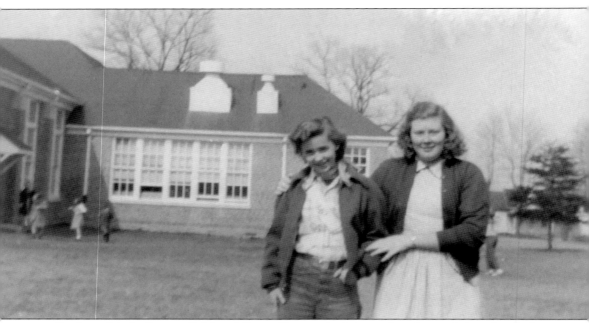

Students Linda Crosen (left) and Peggy Skinner (right) stand in front of the school after its completion. After its closure as a school, the building continued to serve the Sterling community in several capacities, most notably as a community center. (Courtesy of the Crosen family archives.)

Three

AFRICAN AMERICAN CONTRIBUTIONS TO STERLING

POST–CIVIL WAR TO THE 21ST CENTURY

By the time of Loudoun County's recorded formation in 1757, it is estimated that among the region's total population of roughly 3,500 residents, nearly 550—or 16 percent—were slaves. At the onset of the Civil War, there were more than 5,000 enslaved people in Loudoun County. The Civil War exhibit at the Loudoun Museum notes that, at this time, "The free black Loudoun population, consisting of roughly 1,000 individuals who lived in a liminal state as neither slave nor citizen, also faced a greater threat of violent retribution." Abolitionist John Brown's raid at Harpers Ferry in 1859 had forced long-standing debates over slavery in Loudoun County to come to the forefront; a reckoning would prove to be on the horizon with the 1860 presidential election.

Republican candidate Abraham Lincoln received only 12 ballots from voters in Loudoun and Fauquier Counties, likely due to fear from residents of retaliation for voting Republican. Still, Lincoln went on to win the election. The newly formed Confederacy, aware that Virginia had the largest population of enslaved people at the time, hoped to lure the state into leaving the Union; on April 17, 1861, the Virginia Convention adopted an ordinance of secession.

Border wars along the Potomac River ensued. The free Black population (along with Unionists) that had found relative safety in antislavery towns like Waterford and Lovettsville fled Loudoun for greater security across the river due to fear of being forced into slavery by Confederate occupation.

After the Civil War and general emancipation in 1865, African Americans in the area found that despite being free, they had to find ways to build their new lives with little to no resources. At the time, African Americans comprised about one-fourth of the population in Loudoun County, and from this, Black communities developed throughout the area. Most notable in Sterling was the emergence of Nokesville, developed in the late 1800s and named after former slave George

Washington Nokes, who in 1901 became the first Black landowner in Eastern Loudoun when he purchased five acres on the south side of Thayer Road.

The Nokes property operated as a modest farmstead with several outbuildings, including chicken coops and a barn. At the heart of the property was the Nokes house, estimated to be built around 1880. Richard Nokes, the final member of the family to own the property, ultimately sold the land due to growing costs. The home was demolished in October 2021. While the property is slated to be rezoned, the Nokes influence remains evident as Route 637 was renamed Nokes Boulevard and the road runs through what today is the area of Dulles Town Center from Route 28 to Cascades Parkway.

Nokesville was also home to the only Black school in the area. Nokes School opened around 1917 and sat at the corner of what are now Cascades Parkway and Nokes Boulevard. Unfortunately, the school burned down in the early 1920s. In an oral history from 2002, Carrie Nokes, one of the last family members to live on the Nokes property, recalled that after the fire, students did not attend school for two years until her family was able to purchase an acre of land to deed over to the school board.

The one-room schoolhouse ultimately served as both a school and community center but eventually closed during World War II when the number of students attending dwindled. Joan Smith of the Edds family attended the school and remembers times when her teacher, Nannie C. Cole, occasionally stayed overnight at Pidgeon Hill Farm.

While the Nokes and Edds families were considered some of the prominent Black families in the area throughout most of the 1900s, Carrie recounted that segregation during her school years was still a reality. She remembers an incident where she was traveling on the "Old Washington Dominion Railroad" as a child and was required to move out of her warm seat in order to allow a White woman who was cold to sit in it. Desegregation did not take place in Loudoun County until 1967.

Oak Grove, situated between Sterling Road (Route 606) and the W&OD Railroad track near the Fairfax and Loudoun County boundary line, was another neighboring Black community formed by former slaves after the Civil War. While located closer to the western edge of Herndon, Virginia, Oak Grove Elementary School, one of the few schools serving Black students in the area at the time, also hosted Sterling children. Oak Grove Baptist Church, organized originally in 1868, also provided for Blacks in Northern Virginia, including Sterling residents. A 2007 *Washington Post* article noted that by the 1950s, Oak Grove comprised more than 300 people.

In the 20th century, Loudoun County Public Schools (LCPS) was one of the last school districts in the nation to begin desegregation in 1967 following a federal court order requiring LCPS to fully integrate. This came more than a dozen years after the nation's highest court ruled on public school segregation in 1954. In September 2020, the school board, the administration, and the county board issued a public apology for its "blatant disregard and disrespect of Black people."

As the 1900s progressed, Sterling maintained its stakehold in agriculture. However, an often-overlooked part of Sterling's farming history during this time is the inclusion of the African American–owned farms that were vital to the larger Sterling infrastructure. Through the mid-1900s, the Edds, Fitts, Nokes, and Ewings families owned and operated African American–run farms that comprised the areas that now make up Countryside, Cascades, and the Dulles Town Center. In a time when laws continued to be passed that restricted equality and opportunity, these families emerged not only as resilient businesses and landowners but also as key leaders in the area's economy.

$15.00 Received Jany 25th 1851 of Elizabeth Keene fifteen dollars in full for the hire of negroe woman Linney for the year 1850 Alfred Dulin

...January 3rd 1852 of Elizabeth Keene ...n dollars in full for the hire of negroe ...Liney the property of for ...year 1851 Alfred Dulin

Slave labor was a pillar in the workings of Green Plains Farm as shown in slave lease receipts and promissory notes from 1851 and 1852. Here, Elizabeth Keene indicates that she has paid her brother Alfred Dulin in full for the hire of "Linney." (Courtesy of the Robert Edwards Collection, Thomas Balch Library.)

Sterling Virginia
May 15, 1933

Mr O.L Emerick,
Purcellville Va
Dear Mr Emerick
 The patrons of Nokes School, wish
that the school be opened for the year 1933 and 34
There being twenty-two (22) pupils for the incoming
year
 The following parents and friends promise
to support the school

 Mrs. Mary Bigsby
 Mr and Mrs Henry Jones
 Mr. and Mrs Wm. Ellis
 Mr. and Mrs. Clinton Jackson
 Mr and Mrs Henry Bush
 Mr. and Mrs Carl Nokes
 Mr. Clarence Nokes
 Mr John Lambert
Done by the order of the League
 Wm Edds, president
 Mildred Nokes, secretary

This note outlines a petition from William Edds and Mildred Nokes to Loudoun County Public Schools superintendent Oscar Emerick to open the Nokes School for the 1933–1934 academic year. It was signed by eight parents and friends of the school. (Courtesy of the Edwin Washington Project.)

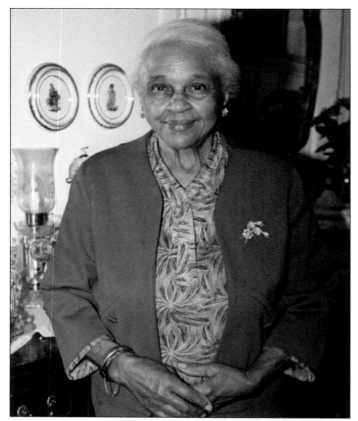

Carrie Elizabeth Nokes lived her entire life in the Sterling area and the Nokesville community. She explained that most of her brothers and sisters were born in the Nokes family house on their property, pictured below. Carrie worked in government service in Washington, DC, for several decades but remained at her home in Sterling until her death in 2008. She recalls Sterling in the 1920s when "Sterling wasn't even on the map. It was just farms, dairy farms, cattle farms, horse farms." (Both, courtesy of Thomas Balch Library.)

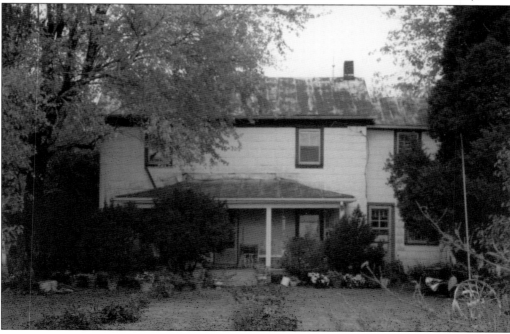

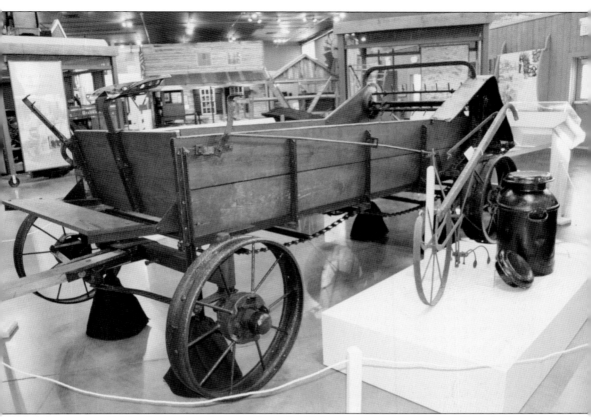

In the spring of 2021, farming implements from the Nokes property were recovered, including a 1930s-era manure spreader, which is now on exhibit at the Loudoun Heritage Farm Museum. It was listed among Virginia's Top 10 Endangered Artifacts for 2021 by the Virginia Association of Museums. The association notes that it was used for decades on the farm and represents the hard work and agricultural legacy of Eastern Loudoun. Restoration efforts included excising a cedar tree from the spreader's frame, dismantling and repairing the running chain, and uncovering the original paint. (Courtesy of Steve DeLong.)

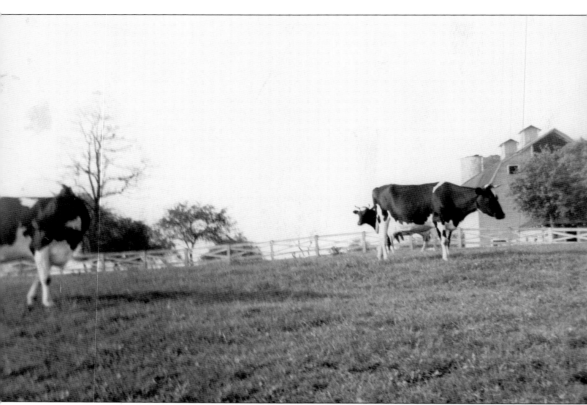

Two couples—William and Flora Edds and Austin and Rosa Fitts—purchased 273 acres of land in Sterling on the north side of Route 7 on January 2, 1918, with 50 additional acres being purchased in December of the same year. The Fittses sold their interest in the farm to the Eddses in 1920; however, the Fitts family continued to help on the farm in various capacities throughout the years. The site went on to be known as Pidgeon Hill Farm. William and Flora raised six children on the farm: three girls and three boys. When their daughter Blanche Edna Edds Martin passed away, they also raised their two granddaughters Joan and Joyce Martin on the farm. Joan Martin Smith recalls that, at its peak, it was the largest dairy farm in Loudoun County, with at least 100 cows. At the time, they picked up milk from both White and Black farmers in the area and took the dairy to Georgetown for pasteurizing and bottling. (Courtesy of Joan Smith.)

Flora, the family and farm's matriarch, was a pioneer in several ways—she was one of the country's first college-educated Black women and the first farmer in the area to use an electric milker. Flora gave Pidgeon Hill its name as the land was typically surrounded by pigeons, and she added the "d" in Pidgeon to make the name more unique. Flora stopped farming around 1960 after years of dedication to Pidgeon Hill Farm and passed away in 1978. Eventually, the land was sold, and most of the property was developed as the planned community of Countryside, though construction of the community would not commence until the early 1980s. (Both, courtesy of Joan Smith.)

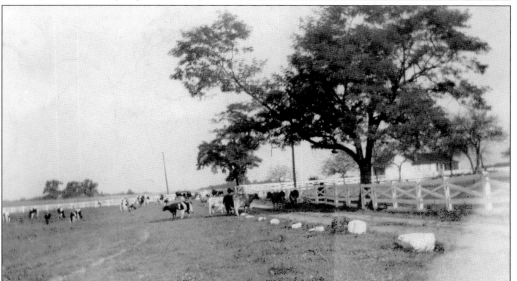

The property was also home to a tavern that eventually became living quarters that were rented out. This dwelling was built as an addition with rocks and stones from the property and came to be known as Rock House. Rock House still stands on the property that is now Sunrise Senior Living, at the corner of Countryside Boulevard and Route 7. Brit Aabakken Peterson recalls renting the house with her family from May 1949 until October 1952, reminiscing that she used to take her sons "cross-country skiing across the fields" where Countryside Marketplace is now located. (Courtesy of Joan Smith.)

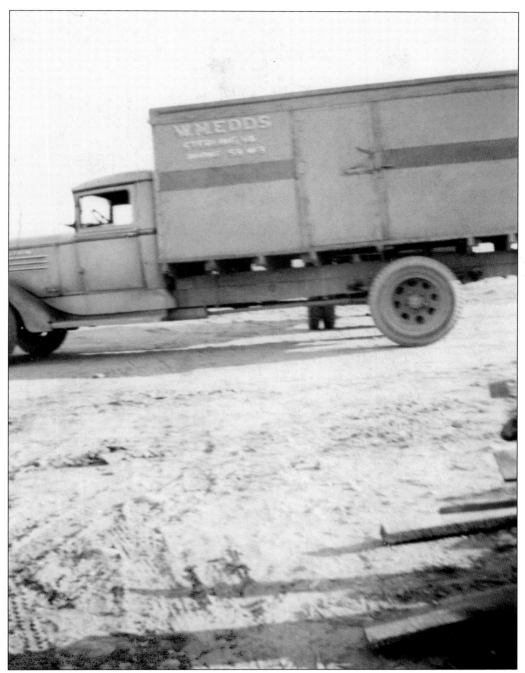

In addition to dairy cows, the farm housed horses, chicken, hogs, geese, bulls, mules, an apple orchard, pear trees, and its own dairy truck (pictured) used for transporting milk. When William passed away in 1938, Flora became the primary manager of the farm. For more than 20 years, Flora ran the farm with the assistance of hired help and other family members. Prisoners from Herndon Junction even helped on the farm during World War II; Flora would feed the men and send them back to camp at the end of the workday. (Courtesy of Joan Smith.)

Iconic to the farm was a towering silo that could be seen from miles away and was integral for storing food for the farm animals, namely cow feed. The silo was constructed of glazed concrete blocks held together with mortar. Smith remembers that while many individuals contributed to the building of the structure, built at least by the 1940s, crucial to its construction was her father, William Martin, a skilled cement finisher. The silo was so well built that it remained a staple Sterling landmark and was even incorporated into the design of the Countryside Marketplace shopping center. The silo was ultimately demolished in 2013 when the shopping center was renovated and it was considered cost prohibitive to maintain or relocate. While the silo no longer stands, longtime residents remember it fondly as a beacon of Sterling; today, a few blocks from the silo remain on display at the Loudoun Heritage Farm Museum. In this picture, the silo peeks out from behind the barn. Pictured in the forefront are Smith's mother, Blanche (left), and aunt Nancy Beatrice Edds Thomas. (Courtesy of Joan Smith.)

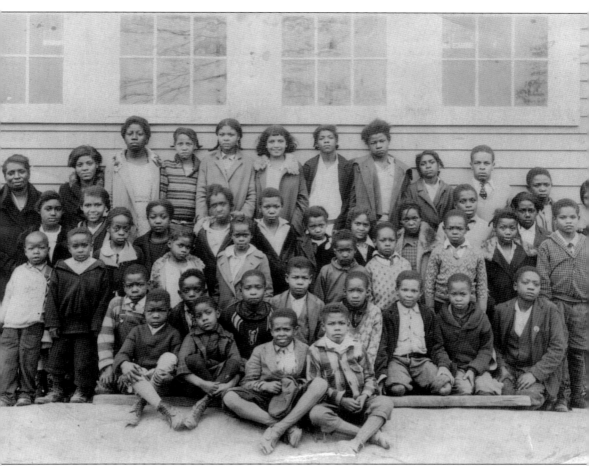

Herndon Town Council records as early as 1881 show evidence of approved expenses for a "colored school" in the Oak Grove community adjacent to Sterling. While it is not clear when the 1800s-era school was established, the subsequent Oak Grove School opened in September 1930. It is believed that the above picture, from the early to mid-1930s, is a class photograph taken outside the two-room schoolhouse, which operated until 1952. A new Oak Grove Elementary School was opened in 1953 at the intersection of Rock Hill and Sterling Roads boasting a six-room brick school building, indoor plumbing, and central heating. When the school closed in 1964, Fairfax County students were transitioned to nearby Herndon Elementary School. Loudoun County students who lived in the Sterling area had to be bussed some 20 miles away to Douglass School in Leesburg, the closest Black school available for them to attend. It was not until 1969, when Sterling Elementary School admitted Black students, that the Loudoun Oak Grove children had a close-proximity school option. (Courtesy of Thomas Balch Library.)

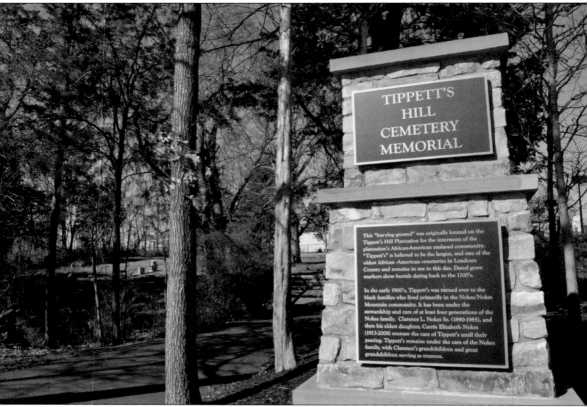

Tippet's Hill Cemetery, located off Moran Road, is not only one of the largest and oldest African American cemeteries in Loudoun County, but it also includes burials from enslaved peoples. Loudoun County records indicate that the cemetery was turned over to Black families in the early 1900s and houses 135 graves as of 2020, with grave markers showing burials dating back to the 1700s. It has been under the stewardship and care of at least four generations of the Nokes family, including Clarence L. Nokes Sr. and Carrie Nokes, until their respective passings. Clarence's grandchildren and great-grandchildren now serve as trustees. (Courtesy of Steve DeLong.)

Four

STERLING'S BOOM YEARS
THE MID-1900S TO THE 1970S

Up through the 1940s and into the 1950s, Sterling was still known predominantly as a farming community. Yet that distinction was about to change. By the late 1940s, a need was identified for a larger airport to support the nation's capital, and after a thorough study of potential locations, a 10,000-acre site 26 miles west of Washington, DC, was selected. The site encompassed Fairfax and Loudoun Counties, including a portion of Sterling. The construction of Dulles International Airport (later renamed Washington Dulles International Airport in 1984) triggered a chain of events that more than 50 years later has driven scores of people to the greater Sterling area for housing and economic opportunities.

In addition to the airport, two major transportation routes (the Washington & Old Dominion Railroad and Leesburg Pike) and future sewer line extensions made Northern Virginia's potential for expansion even more evident. By October 1959, Lehman Brothers, one of the world's largest banking firms, surfaced plans to buy up vast tracts along Broad Run and from Sterling west to Ashburn.

In tandem, housing developer Marvin T. Broyhill Sr. sought to capitalize on the area's impending growth by making plans for a piece of land east of where Lehman Brothers set its sights. From April to December 1961, M.T. Broyhill and Sons Corporation bought 1,762 contiguous acres of land, and the "New City at Sterling" was unveiled to readers of the *Loudoun Times-Mirror* on August 17, 1961. Broyhill's intent was to build prefabricated homes marketed by US Steel to be sold for about $17,000, which was $3,000 less than what a comparable home cost in neighboring Fairfax County.

Sterling's beginnings, however, were not without trials. The initial plan for the community was declined by the Loudoun Board of Supervisors in August 1961. The second vote in May 1962 was initially approved but then canceled a few days later due to Broyhill's neglect to post notices in the Sterling area about the proposed planned community. A plat, "Broyhill's Addition to Sterling Park," was filed on May 15, 1962. The extended name was needed because of a small 1945 Sterling Park subdivision south of Sterling village; the county would not allow two subdivisions to possess the same name. Finally, on June 12, 1962, the board approved Broyhill's plans. By July 21, 1962, the first 10 homes were built and 66 families had already put down deposits of $200 for the community. By February 23, 1963, the first 15 families of Sterling moved into their new homes.

Regarding race covenants at the time, in a 2002 article, historian Eugene Scheel recalls how "[t]he original Sterling Park and 'Broyhill's Addition' had one thing in common. Residents had to be of the 'Caucasian Race.' No board member or speaker before the board raised an objection to

the clause, a common one in the United States throughout the 1960s, even though discriminatory housing was outlawed by the Civil Rights Act of 1866." No Black family moved into Sterling Park until 1966, when the population had reached 5,000 and the illegality of the clause became apparent.

Infrastructure building problems also arose. In a *Loudoun-Times Mirror* 25-year retrospective on Sterling, Richard Gray, a comptroller hired by US Steel and one of the first residents of Sterling, recalled, "The original sewer and water contractor had problems and the models on Ash Road to Beech Road and all the way down Beech, two miles of them, had to be dug up and re-laid. This affected 100 or more homes."

Despite these issues, progress steadily continued. In a 1967 *Home Builder* article, Thomas Quinn, who was involved in the early development of Sterling Park, spoke of his hope to build a community that would correct the mistakes of big cities and create a small-town atmosphere that would provide for the needs of multiple generations. As homes went up, other aspects of the community began to develop and flourish in turn. Church congregations were initiated, schools were built, and planning for the library and community centers was underway.

A June 1963 newspaper article referenced stores to come to the Sterling Park Shopping Mall: "Safeway Stores, Inc., will be the first supermarket to serve residents of Sterling Park in the Loudoun County community's new shopping center. When completed, the center will consist of 68-acres of enclosed mall shopping. Parking space is planned for 4,500 cars. Development of the center will be in three phases." Later that year, Marvin T. Broyhill Jr. signed a lease to bring the 12,000-square-foot Peoples Drug Store to the shopping mall as well.

Public safety institutions were also being established. By 1966, the humble origins of the then Sterling Volunteer Fire Department (SVFD) began to crystallize. Though the department had no equipment, no home, and no money to start, within 10 years, the SVFD would establish itself as a major operation amassing two new pumpers, a Jeep, a chief's carryall, and a new 100-foot ladder truck.

Recreation facilities commenced, too. The Sterling Park Golf Swim and Tennis Club was built and boasted impressive amenities, including a 70-acre recreational club, an 18-hole, par-three golf course, a swimming pool, a wading pool, a pro shop, a bathhouse, a snack bar, four tennis courts, basketball courts, baseball diamonds, a picnic area, and a park.

Sterling's boom years would explode throughout the 1960s and continue until the end of the 1970s. By August 1967, there would be 1,081 homes, 292 rental townhouses, 1,373 families, and an estimated population of 5,630 people based in Sterling. New elementary schools (Sterling Elementary, Guilford Elementary, and Sully Elementary) would be built, along with a middle school (Sterling Middle) and high school (Park View) to support the area's rapid growth. By the late 1970s, Sterling's subdivisions also experienced expansion with the development of the Forest Ridge and Oak Tree subdivisions.

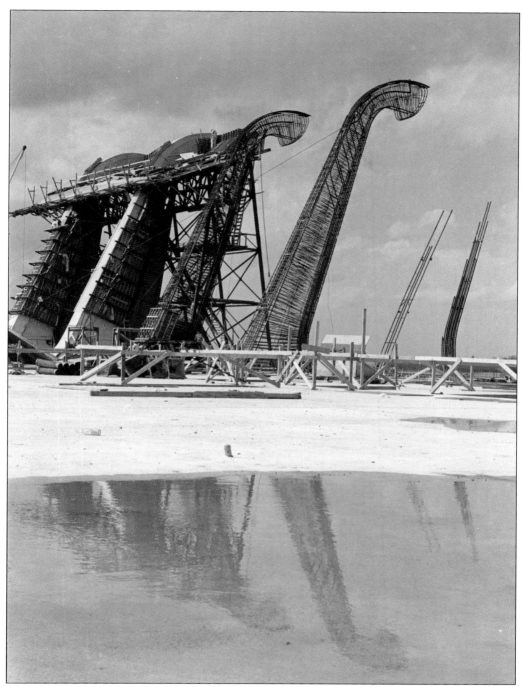

The idea of placing an airport at Burke, Virginia, was proposed before 1957, and some acreage was purchased, but other areas were considered. In August 1957, Congress appropriated $12.5 million, and Pres. Dwight D. Eisenhower was tasked with buying land for a jet-age airport to serve as a secondary airport for the nation's capital. Here, massive support towers begin to get erected on the site. (Courtesy of the Library of Congress.)

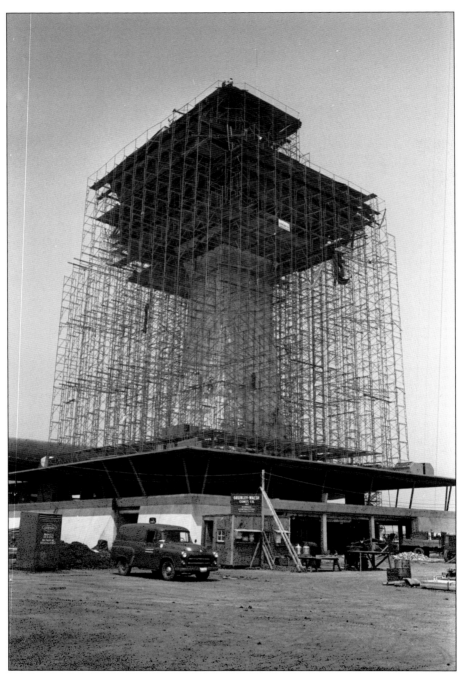

The immense size of the site where Dulles International Airport (IAD) was ultimately placed allowed for the airport, the first in the country designed for commercial jets, to be buffered from its neighbors. Construction of the airport in turn brought attention to Sterling as a viable option for families to live outside the Washington, DC, area as government workers could commute into the city and reap the benefits of cheaper housing and more land. Here, the airport's control tower is being constructed. (Courtesy of the Library of Congress.)

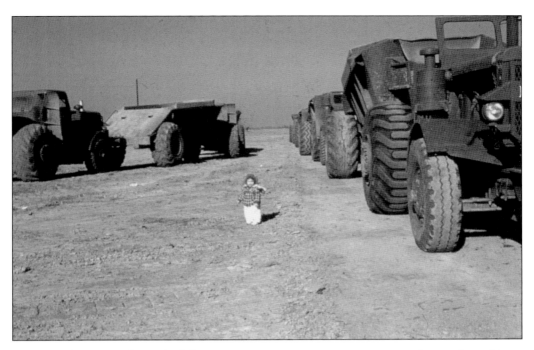

Watching the airport being built became a spectator sport—it was common for nearby residents to visit the site to gauge progress. Baby Carolyn Crosen (pictured above) poses beside trucks that hauled sand and gravel, while Shirley Crosen's Pontiac (pictured below) is shown next to bulldozers readying the land. The landscape transition from empty fields to bustling airport would crystallize quickly. (Both, courtesy of the Crosen family archives.)

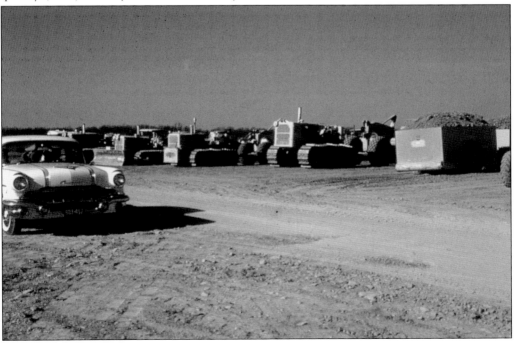

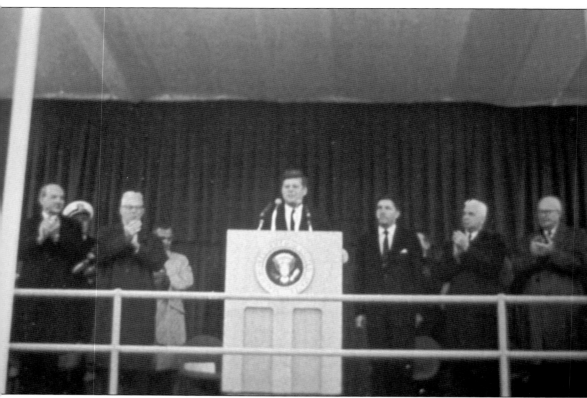

Dedication Day for Dulles Airport took place on November 17, 1962. Pres. John F. Kennedy and former president Dwight D. Eisenhower each spoke and had high praise for the public and private citizens who played a part in the airport coming together. Former Virginia senator Charles Waddell was also at the dedication; he would start his career in airlines at Dulles in 1963 and work for the airport for another 25 years. (Courtesy of Metropolitan Washington Airports Authority.)

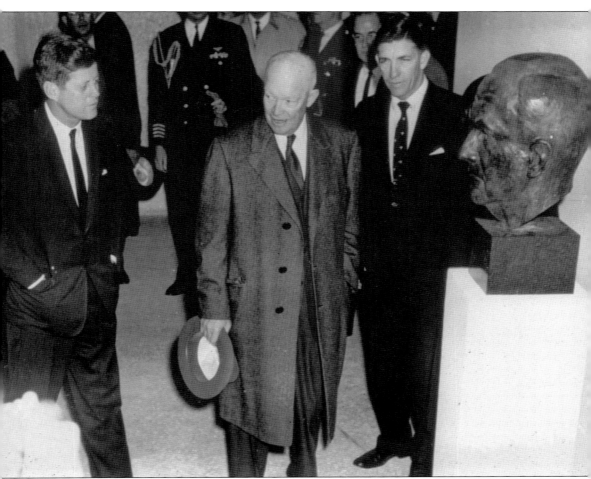

Presidents Kennedy and Eisenhower are pictured next to a bust of John Foster Dulles, for whom the airport was named. Dulles was Eisenhower's secretary of state and passed away in 1959, prior to the airport's official opening. His widow, Janet, attended the ceremony. From the grand opening through the end of 1962, the airport served 52,856 passengers. Annual passenger traffic would reach one million by 1966. IAD's terminal has since been made twice as large, with an additional section added to each end of the main building. The addition of a larger building was in architect Eero Saarinen's original design due to projections for increased airport traffic. Today, IAD is considered one of the busiest airports in the world. (Courtesy of Metropolitan Washington Airports Authority.)

The construction of the airport brought with it a contract for sand shipped to Sterling. This and other materials from local quarries would arrive at Sterling Station and be trucked to the airport a few miles south. After the construction of the airport, the W&OD Railroad, whose freight business had been on the decline, enjoyed a resurgence of activity. (Courtesy of Nova Parks.)

Ultimately, this temporary spike could not save the railroad—the W&OD limped along for another six years before operations officially shut down in August 1968. Virginia Department of Highway workmen placed asphalt strips over the abandoned tracks of the W&OD railroad line at its crossing on Route 659 south of Route 7. (Courtesy of Claude Moore Park archives.)

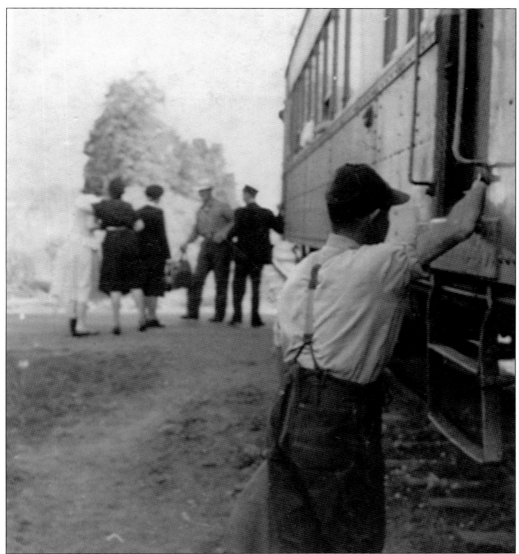

There was opposition to closing the W&OD—in a letter to the governor on February 25, 1965, Congressman Joel T. Broyhill (brother of Sterling's developer Marvin Broyhill Jr.) asserted that while he supported the Virginia Highway Department's efforts in proceeding with the highway construction program, care should be exercised to ascertain what impact the elimination of the railroad would have on the area's industrial future as he feared that such a move would reverse Northern Virginia's success in attracting new commerce. (Courtesy of the Crosen family archives.)

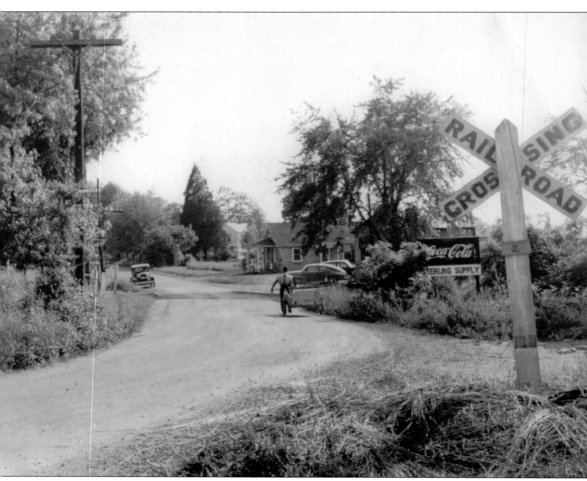

Other dissenters included the Leesburg Town Council, which voted unanimously to oppose the proposed sale of the railroad, and Northern Virginia Transportation Commission chairman Frederick A. Babson, who advanced the idea of Virginians banding together to purchase the railroad. Here, a man heads back to the post office after the last mail run from Sterling on May 31, 1957. (Courtesy of the Crosen family archives.)

Thomas Quinn, vice president of American Modular Corporation, a subsidiary of United States Steel Homes Credit Corporation, which financed the construction of Sterling Park, hoped to create a community for the people with recreational facilities, a community center, libraries, and space for volunteer fire and rescue crews. Within just a couple of years, many of these goals would be realized. Discussing early roadblocks, Quinn explained, "There were suits because people who were already out here said that their wells had gone dry because of our construction but we won those. Then they [Board of Supervisors] wouldn't give us commercial zoning for the frontage on Route 7." Here, the two-million-gallon-capacity water tower near Sully Elementary School is being constructed by the Loudoun County Sanitation Authority. (Both, courtesy of Claude Moore Park archives.)

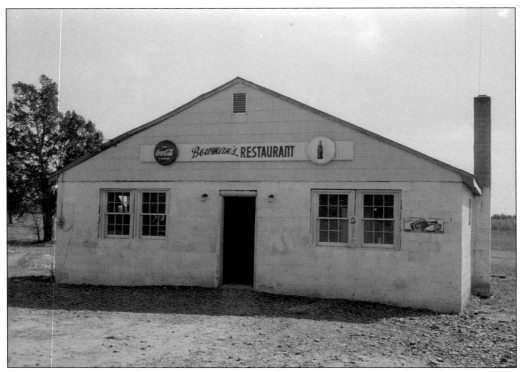

One of the earliest community organizations was the Sterling Ruritan Club. While the club officially began on November 21, 1951, and served the Sterling community throughout the early 1950s, it was not until 1956 when the club purchased the building housing Bowman's Restaurant for $8,000 to serve as its headquarters. The first meeting was held in the clubhouse in February 1959, and ground was broken for a building addition in 1964. (Courtesy of Thomas Balch Library.)

The 1960s were a decade of supporting the growing infrastructure in Sterling. The Ruritan Club voted to sponsor a new water line to be installed in Sterling, as well as sponsoring meetings with the sanitation authority to discuss potential sewer services for the town. The clubhouse still stands off Ruritan Road, and the club continues to serve the Sterling community through various initiatives. (Courtesy of Sterling Ruritan Club.)

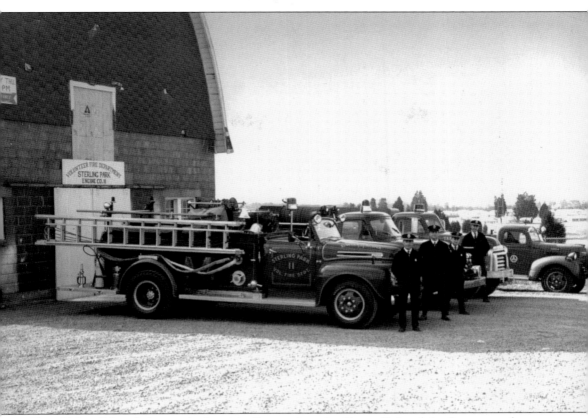

The old Lee Edwards barn, which originally stood on the Green Plains dairy farm, served as a landmark in Sterling Park from the beginning and was home to a number of organizations. The Sterling Volunteer Fire Department was given use of the barn on West Holly Avenue by the Building Corporation at no charge, but clean-up and renovations proved problematic. Upon move-in, the ground floor, which had previously housed milking stalls, was converted into offices, a day room, and vehicle bays. On snowy winter nights, snow blew through cracks in the building and window frames. The company also shared the building with a resident skunk for some years. (Courtesy of Marvin Miller.)

Here, a fire department truck is visible in the background while incoming Sterling Park Jaycee president Richard Smith (left) and development corporation head Thomas Quinn (right) review plans for remodeling the barn. In May 1968, US senator Harry Flood Byrd Jr. officiated at the formal dedication of the building as the first Sterling Park Community Center. A crowd of 300 attended the ceremony where Byrd cut the ribbon to the building and officially opened the renovated second floor that served as the community center. The barn's opening as a community center included a staff of one and modest facilities, but it still marked the beginning, nonetheless. (Courtesy of Claude Moore Park archives.)

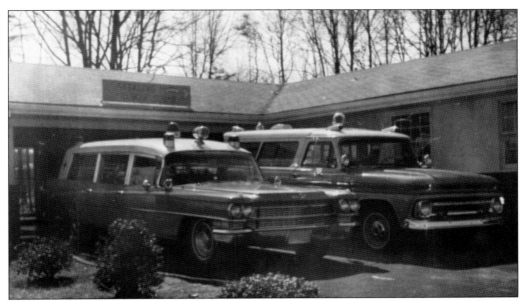

The Sterling Park Rescue Squad was founded in 1964 as a result of the Sterling Park Jaycees "Grand Project," first proposed by John A. Costello, charter president of the Sterling Park Jaycees. In the early years, volunteers responded to calls from their homes. The first call was run on February 27, 1965, and involved a motor vehicle accident. As the organization continued to grow in response to the needs of the community, an additional ambulance was purchased. In November 1967, the squad formally moved into its first headquarters at 304 North Sterling Boulevard. This February 1965 photograph is believed to be the first taken of the department, pictured in front of its first ambulance, a 1959 Chevrolet Carryall purchased from Manchester Rescue Squad. (Both, courtesy of Sterling Volunteer Rescue Squad.)

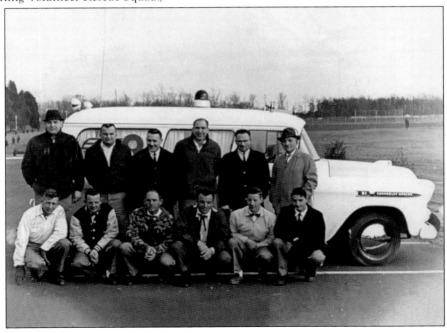

In June 1966, the rescue squad and the Jaycees put out an all-hands call to form a fire service by posting notices around the Sterling Park Shopping Center and on telephone poles. The Sterling Park Volunteer Fire Company was chartered on August 16, 1966. This 1970s photograph shows both the rescue squad and fire companies pictured together. At 3:30 p.m. on November 19, 1966, the fire company was dispatched for the first time to a barn fire in Sterling Park. Thirteen members responded along with the Ashburn Volunteer Fire and Rescue Department and Herndon Company 4 (now part of Fairfax County Fire and Rescue Department). While no photographs exist from that first call, the Sterling Volunteer Fire Company hosts a large visual collection from its earliest history. (Both, courtesy of Marvin Miller.)

One of the oldest recorded congregations in Sterling was Lebanon Grove Baptist Church, founded in 1857. In 1873, the church changed its name to Guilford Baptist Church to reflect the name of the surrounding community. It often served as a circuit church, sharing a minister with other Baptist churches. The church was closed periodically throughout the 1940s and 1950s but remained open from 1954 to 2013. In the summer of 2013, Guilford merged with Sterling Park Baptist Church, which sits at North York Road. (Courtesy of the Crosen family archives.)

Sterling Methodist Church, established in 1875 as the Methodist Church in Guilford, occupied a one-room building that was also used as a school located on West Church Road. In March 1897, the original structure burned down, but within two years, a new building was erected on the same site and remained in existence until 1983. On October 30, 1983, the old building was deconsecrated, and the church moved into the new building on East Church Road. (Courtesy of the Crosen family archives.)

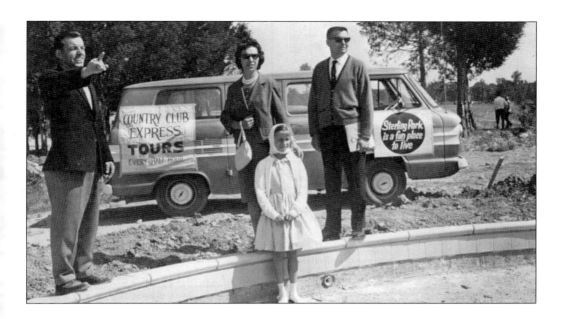

In an effort to promote the expansion of Sterling Park, tours were offered to show off the community's amenities and building efforts. Pictured above, Bill Swick shows off the future Sterling Park Rec Center to an interested family. Pictured below, the organizing committee of the Sterling Park Citizens Association met in October 1963 to draft bylaws. Members included Richard D. Gray, corresponding secretary; Walter R. King, vice chairman; Alfred H. LaPlaca, chairman; James Goldsborough, sergeant at arms; and Roy R. Gresham, recording secretary. (Both, courtesy of Claude Moore Park archives.)

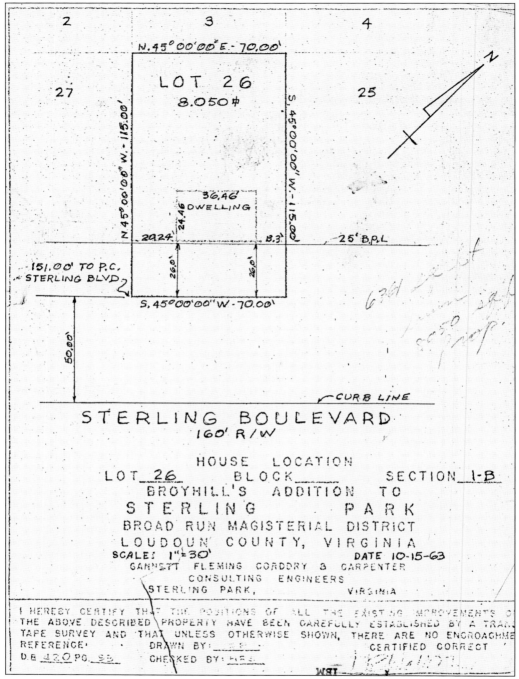

On February 14, 1963, the families of Tom, Terry, and Janet Brooks and Paul and Dorothy Stone bought the first properties in "Broyhill's Addition to Sterling Park." By the spring of that same year, some 50 more families would settle into Sterling Park. The original lot paperwork from the Ford family shows the early details of their property on Sycamore Court from October 1963. (Courtesy of the Ford/Kerico family archives.)

The Glen Ora

CENTRALLY AIR CONDITIONED

This spacious four bedroom, two bath split-foyer floor plan has become the most popular style in the Washington area. Your social status will definitely rise when you entertain in the ballroom size recreation room.

Ultra-Modern GE appliances include: Refrigerator, Garbage Disposal, Electric Range and Oven, and Clothes Washer.

Sterling Park

The original sales brochures for Sterling Park highlighted several models available for sale while also touting such amenities as central air conditioning and modern GE appliances. One of the first families to move into Sterling Park, the Brooks family, bought the Glen Ora model, pictured above. The name was mirrored after the Kennedys, who would move into an estate of the same name in 1963 located south of Middleburg in Fauquier County. Other models included those named after other Loudoun County communities such as the Arcola, the Hillsboro, and the Wheatland. (Courtesy of the Ford/Kerico family archives.)

A NEW LEVEL OF LEISURE LIVING

Sterling Park

IN PICTURESQUE NEARBY VIRGINIA

The Broyhill marketing team did attach restrictive covenants to its development. According to a *Loudoun Times-Mirror* historical retrospective on Sterling Park, "No dwelling was to cost less than $10,000; the minimum square footage of a one-story house was to be 890; of a two-story house, 1,390; no house could exceed two and one-half stories or have a garage that could hold more than two cars." Broyhill's vision for Sterling as a "true planned community" included a promise of business and industry as well as a greenbelt. This vision was based on the concept of small neighborhoods each with a shopping center. While this did not materialize exactly as originally conceptualized, Sterling did grow—and quickly. (Both, courtesy of the Ford/Kerico family archives.)

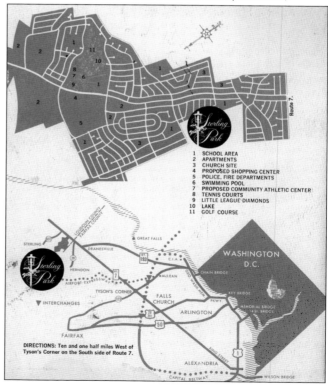

1 SCHOOL AREA
2 APARTMENTS
3 CHURCH SITE
4 PROPOSED SHOPPING CENTER
5 POLICE, FIRE DEPARTMENTS
6 SWIMMING POOL
7 PROPOSED COMMUNITY ATHLETIC CENTER
8 TENNIS COURTS
9 LITTLE LEAGUE DIAMONDS
10 LAKE
11 GOLF COURSE

DIRECTIONS: Ten and one half miles West of Tyson's Corner on the South side of Route 7.

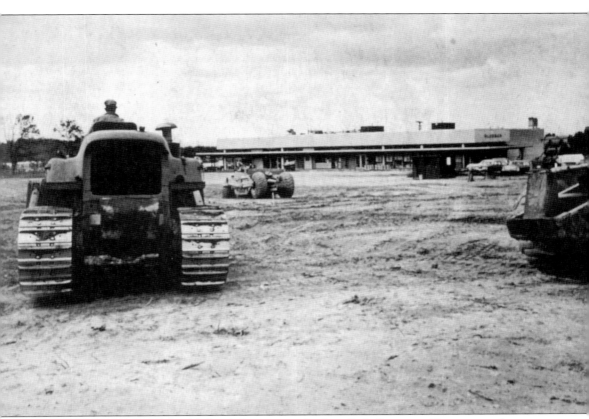

By 1967, more land was cleared behind the existing Sterling Park Shopping Center to make way for expansion and additions to the center in parallel with an increase in the community's growing population. The expansion enabled Safeway to move to a new store more than triple its original size as well as a relocation of a much larger Peoples Drug Store. In a *Loudoun Times-Mirror* article from July 1967, Thomas Quinn envisioned that the center would "make it possible for residents to do 'one-stop' shopping in Loudoun County for all their needs." (Courtesy of Claude Moore Park archives.)

In 1970, the need for a dedicated fire station was apparent, and the Sterling Volunteer Fire Department and the Sterling Volunteer Rescue Squad agreed to a joint house and formed the Sterling Park Safety Center Corporation. US Steel leased the land to the corporation for $1 per year for 10 years, with the group to purchase it for $2 per square foot (then valued at $8 per square foot). The final build cost $150,000. In June 1972, the Safety Center on Commerce Street was officially dedicated with a ribbon cutting and large party. (Courtesy of Marvin Miller.)

The Sterling Volunteer Fire Department would become one of the busiest stations in the county, establishing the first junior firefighter program from which participants would go on to become chiefs, captains, and other ranking officers. The department was also groundbreaking in not only hiring the first career firefighters but also serving as a driving force in promoting modern fire suppression operations in Loudoun County overall. (Courtesy of Marvin Miller.)

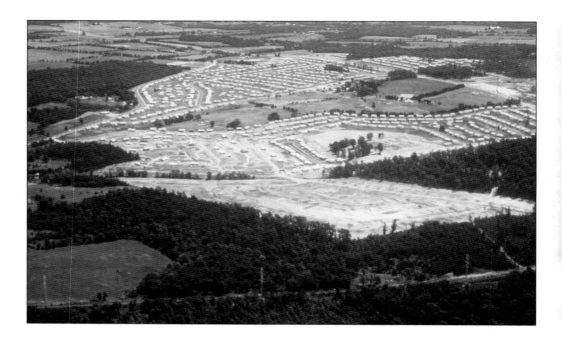

Aerial photographs showcase how quickly the landscape of the area changed at the onset of development from that of predominantly farmland to suburban sprawl. The photograph above shows the land under construction in 1965; below, Sterling Park is nearing completion in 1969. (Both, courtesy of the Fairfax County Public Library Photographic Archive.)

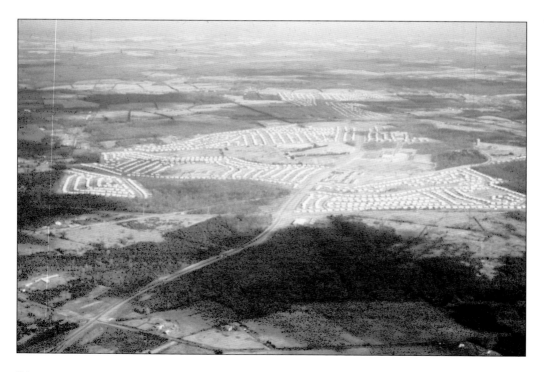

As the community grew and changed, so too did the number of churches. On March 5, 1972, Fr. Ken Dougherty celebrated the first mass for Christ the Redeemer Catholic Church in the cafeteria of Sterling Middle School with 500 attendees. Bishop John J. Russell established the parish at its permanent site on June 1, 1972. Pictured here, Rory Joseph McCarthy, Josephine and David McCarthy's grandson, is christened on the McCarthy property in the fall of 1979 by Rev. Edward F. Gallagher Jr. of Christ the Redeemer. Today, Christ the Redeemer is a multicultural parish comprising 4,700 households with mass and prayer held in multiple languages. (Courtesy of Linda McCarthy.)

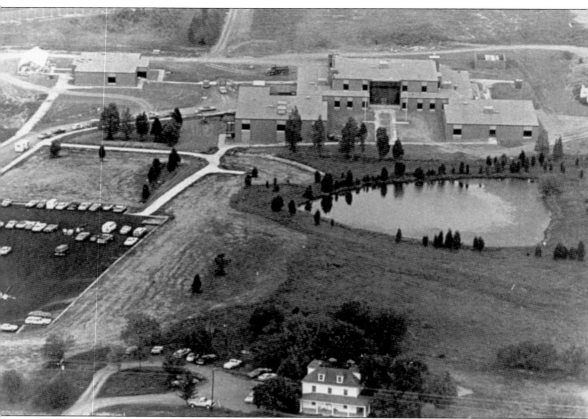

Northern Virginia Community College, established in 1964 under the name Northern Virginia Technical College, is currently the third-largest multicampus community college in the United States, composed today of six campuses and four centers. Construction on the Loudoun Campus in Sterling began on a 91.4-acre site in 1972 and was completed and opened in 1974 with four permanent buildings, a temporary Interior Design Building, and greenhouses and laboratories. This aerial photograph of the Loudoun Campus in 1974 shows what the campus looked like at its inauguration. (Courtesy of NVCC Loudoun Campus archives.)

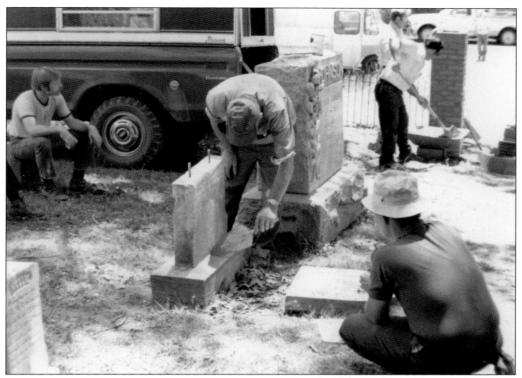

In 1976, initial restoration efforts were undertaken to preserve the old Sterling Cemetery. The Sterling Ruritan Club helped remove dead trees and undergrowth while the old wrought iron fence was repainted. Headstones were reinstalled and straightened with the inscriptions recovered and preserved by rubbings. Also in 1976, members erected the flagpole at the Ruritan Club on Ruritan Road. In the distance, the sign for the Sterling Park Shopping Mall can be seen. Throughout the 1970s, dances were held at the club every Saturday night. In 1975, the club worked with the American Legion to erect a veteran's memorial that still stands across from Sterling Middle School. (Both, courtesy of Sterling Ruritan Club.)

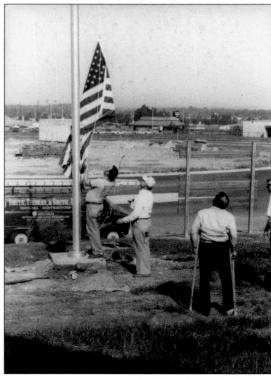

The rapid expansion of the Sterling area included the youth sports arena. In 1963, the Lower Loudoun Little League was formed. Charlie Waddell, the league's founding vice president, reflected that the league was born out of necessity as children in the area did not have a place to play organized sports and had been previously playing informal sandlot leagues in the Broad Run Farms area behind Galilee Church. Waddell remembers that the league was inaugurated with three teams—the Broad Run Twins, Sterling Indians, and Ashburn Orioles—and from there "grew like a giant oak from an acorn's grove." A 1971 Lower Loudoun Little League roster pamphlet further commented on the league's progress over the years, stating that since 1966, the program had grown "from 10 teams and 150 boys to 38 teams and 580 boys." There were up to 1,500 league participants in the early 1990s, yet that number shrank when the construction boom began in Loudoun County and Little Leagues were also formed in Ashburn, Leesburg, and South Riding. (Courtesy of the Ford/Kerico family archives.)

By the fall of 1964, overcrowding in the 1946 Sterling Elementary School resulted in children being bussed to Catoctin Elementary in Leesburg and Ashburn Elementary as well as some students being taught in the Sterling Ruritan Club. In February 1965, the new Sterling Elementary School opened, and problems abated for a period of time. Construction on Guilford Elementary, completed in 1966 and located off West Poplar Road in Section 2, commenced to further aid in alleviating the influx of Sterling children. Here, a group of men helps break ground for the school, including in the foreground Mayhew W. Siess, architect; C.M. Bussinger, superintendent of Loudoun schools; Fern Marshall, school board member; and atop the bulldozer Alex Sweney, an additional architect. The school cost approximately $528,000 to complete. (Both, courtesy of the Ford/Kerico family archives.)

Sully Elementary, seen here under construction, was opened in 1968, necessitated by continued overcrowding of the two existing elementary schools. Due to the urgent need, the school's official opening took place before the completion of all its facilities—originally the school did not have a finished cafeteria, office, or library. Nor was there a working telephone at the offset; emergency information was run from Guilford Elementary to Sully Elementary by car. According to a September 1968 *Loudoun Times-Mirror* article, although the school was "far from completion, it will house some 500 schoolchildren this year." (Courtesy of the Ford/Kerico family archives.)

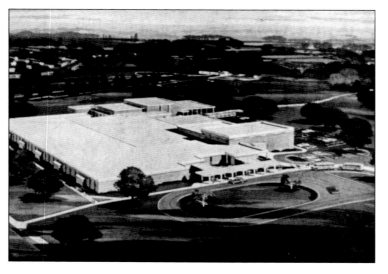

By mid-1969, the Loudoun County School Board received a $2.3-million bid from construction firm Burroughs and Preston to build the proposed Sterling Park Middle School. Pictured is one of the original renderings from the architect firm Dixon and Norman, designers of the school. The building was completed in 1971. (Courtesy of Claude Moore Park archives.)

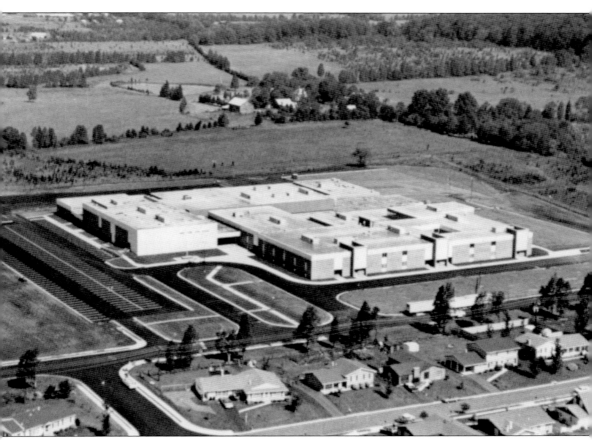

In August 1969, Broad Run High School was opened, much to the dismay of Sterling residents—the location of the school was inconvenient for many families, and sentiment arose that it should be placed closer due to Sterling being one of the first large subdivision towns in Loudoun County. By the early 1970s, it was clear that a new high school was needed in Eastern Loudoun to serve the growing Sterling Park community. Construction for a school began in 1974. Park View High School was opened in 1976 to tremendous community support—a parent boosters club raised more than $15,000 the first year to support extracurricular activities. Completed at a cost of $7.4 million, the structure was impressive by standards at the time and included a two-story media center, large auditorium, and 1,500-capacity gymnasium. (Courtesy of Phil Rosenthal.)

As Sterling Park grew, so too did the need for a larger and more responsive community center. Construction began on a parcel of land provided by a developer adjacent to the Sterling Park Safety Center on Commerce Street. On September 1, 1977, the 17,500-square-foot facility was opened to the public. In addition to the community center, the building also housed the Sterling branch of the library, a substation of the sheriff's department, and a branch of the treasurer's office and Loudoun County Sanitation Authority. (Courtesy of Nick Wilt, Sterling Community Center.)

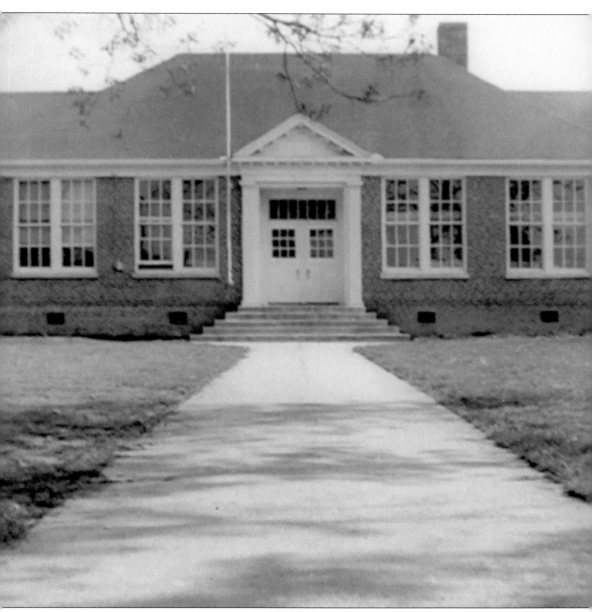

Even with the introduction of the new community center in 1977, the area's rapid growth necessitated even more space. By 1979, Sterling needed another building to support the amount of activity and visitors. The Sterling Community Center Advisory Board approached the Loudoun County School Board to request the use of the old Sterling Elementary School, which was being used as a storage facility. A five-year lease for its use was signed in May 1981, and after a large renovation, the former school building opened as the Sterling Annex Community Center on January 2, 1982. The building went on to host various community meetings, events, classes, and summer camps in intervening years. (Courtesy of the Crosen family archives.)

Park View's athletic programs grew in the years following its opening with a number of athletes going on to college and professional sports careers. Here, Allen Pinkett, who grew up in the Sterling area and attended Park View from 1978 to 1982, makes a run during a football game. Pinkett became a two-time All-American at Notre Dame and played six seasons for the Houston Oilers in the National Football League. (Courtesy of Phil Rosenthal.)

Five

STERLING TODAY

THE 1980S TO THE PRESENT

While Sterling's burst of housing growth tapered off in the 1980s, commercial growth came in the way of business and shopping center development. In December 1987, Loudoun County officials approved the jurisdiction's first regional shopping mall, originally planned to be named the Windmill Regional Shopping Center but later renamed to Dulles Town Center in 1988. The original expected opening was set for 1993, but delays postponed the occasion; the mall's official ribbon-cutting ceremony did not take place until August 12, 1999.

By the 1990s, Sterling's commercial infrastructure evolved as the internet grew and data centers began proliferating in Loudoun County. Multiple sources estimate that more than 70 percent of the world's internet traffic passes through fiber laid in Northern Virginia, dubbed "Data Center Alley." Perhaps most instrumental to that development was America Online, which officially housed its headquarters in Sterling in mid-1996. With the arrival of AOL came fiber and the power infrastructure to expand it. Today, the internet is housed in the dozens of data centers located throughout Sterling and Loudoun County, making the region the biggest data center market in the world.

In addition to infrastructure changes, many of Sterling's lasting landmarks have experienced changes over the years. After Dr. Claude Moore donated land from Claude Moore Park to the National Wildlife Federation (NWF) for environmental and educational outreach in 1975, a bitter and highly publicized conservation dispute ensued. According to Loudoun County Parks, Recreation, and Community Services, "The NWF sold the property to developers in 1986 and Dr. Moore fought an unsuccessful multi-year fight in the courts to block the sale of the property. After the case was decided, Loudoun County purchased the property from the developers. Loudoun voters approved a bond referendum for the purchase, supporting Dr. Moore's vision that this historic and natural property be kept as open space for active and passive recreation."

The county officially opened Claude Moore Park in 1990 with the help of many volunteers. Today, the park contains a blend of natural habitats, historic areas, hiking trails, educational activities, and active recreation facilities. A 2003 article from *Loudoun Wildlife Conservancy* highlights the park, stating, "Significant natural features include a section of forest that state biologists have cited as an intact example of a mature southern hardwood forest undisturbed by logging or other human activities. The park also hosts two strands of Prickly Ash, a threatened species of tree in Virginia and a source of food for the endangered Giant Swallowtail butterfly. Mature forests in the park include oak trees that date from the colonial era."

Several additional subdivisions were formalized in subsequent years within Sterling's borders. Sugarland Run, named for a stream flowing toward the Potomac River along the east side of the community, was built in the 1970s in the style of Sterling Park with a primary shopping center and community pool. The housing development of Countryside was conceived in the mid-1970s when 1,000 acres of what had been farmland was divided in preparation for a planned housing development. Construction began in 1983 and continued through 1991. Another planned community, Cascades, comprises 2,500 acres with its homeowners association being incorporated in 1990.

Many of Sterling's existing community buildings have been upgraded and expanded over the last 30 years. On October 3, 2021, the Sterling Safety Center, originally dedicated in 1972, was demolished to make way for a modern facility. The new 22,000-square-foot facility will replace the 8,772-square-foot building and provide more storage and parking. The community center was also completely refurbished, expanded, and reopened in 2022. The Sterling Public Facilities Master Plan initiated an extensive plan by the board of supervisors in 2012 and began construction in 2020. Improvements included an addition of 2,000 square feet to the existing 18,700-square-foot facility, renovations to the outdoor pavilion, the addition of an outdoor amphitheater, and the creation of new lawn areas. Despite these wins, a number of institutions have also fallen into disrepair, namely the old Sterling Elementary schoolhouse. Efforts have been surfaced by residents, with varying levels of success, to prevent future historic structures from being abandoned or demolished.

Park View High School, touted for its innovative features when originally built, is also slated to be demolished entirely in favor of a newly constructed building projected to open in August 2027. After originally considering renovation of the original site, it was determined that the age of the building, along with cramped conditions, necessitated a complete rebuild. The new site will include a brand new stadium and athletic fields and expanded capacity.

In March 2021, the 10-acre property that had belonged to the Nokes family was demolished after being sold for $5 million. Richard Nokes, nephew to the late Carrie Nokes, was the final member of the family to own the property and had to sell it due to escalating costs. While the demolition was disheartening for many longtime residents who remembered the property fondly, the Nokes name remains visible in Sterling with Route 637 now officially known as Nokes Boulevard.

The ethnic makeup of Sterling has also evolved considerably since its inception—a key finding of the Northern Virginia Regional Commission from the 2020 census shows that the Hispanic population of Northern Virginia has been one of the fastest-growing populations within the region over the past two decades. In tandem, additional churches have opened in Sterling in recent years to accommodate the growing community and roster of faiths. The Northern Virginia Bahá'í Center opened in September 2007 to serve people of all backgrounds with a focus on spiritual transformation, while the ADAMS Center, established in 1983, serves the local Muslim population. Today, this shift of increased diversity showcases Sterling as a unique cultural hub that now houses international grocery stores, a variety of restaurants showcasing global cuisines, and a melting pot of people who share Sterling as their home.

Today, Sterling sits firmly within the Dulles Technology Corridor, a geographical cluster located in Northern Virginia that features a heavy concentration of defense and technology companies, namely data centers. Dubbed "the Silicon Valley of the East" by the *Atlantic*, the area is anchored largely along and between Virginia State Routes 7 and 267. (Courtesy of Tom Fish.)

Algonkian Regional Park, near Cascades and Countryside in Sterling, is a popular site with miles of hiking trails, vacation cottages, an outdoor water park, and an 18-hole golf course. The Northern Virginia Regional Park Authority acquired the land in 1975 from the Potomac Electric and Power Company (PEPCO). In the 1950s, the county board of supervisors voted to have a power plant built, and PEPCO planned to construct a coal-fired plant along the Potomac River. The Washington & Old Dominion Railroad, which at this time was owned by the Chesapeake & Ohio Railroad, was intended to be a primary force controlling the shipping to the plant. The plan fell through when Maryland made PEPCO a better offer, and the power plant that could have been in Sterling along the Potomac River never was. (Courtesy of Nat Thanapohn.)

Walkers, runners, and cyclists can traverse the 44.8-mile trail that once made up the route of the W&OD Railroad. The trail starts in Arlington and winds through Fairfax County, nearby Reston, and Sterling (part of the trail pictured above), extends through to Leesburg, and ends at Purcellville Train Depot. A project has been initiated and slotted for completion in 2026 that would entail the Loudoun County Department of Transportation and Infrastructure to construct a pedestrian/bike bridge over Sterling Boulevard to separate users of the W&OD trail from roadway traffic. (Courtesy of the Historical Marker Database, Craig Swain.)

Since its inception in 1974, the Loudoun Campus of Northern Virginia Community College has seen several additions to its original campus with the first being the Phase II Expansion. An architectural model shows the expansion layout, which includes the Waddell Building and Reynolds Building. (Courtesy of NVCC Loudoun Campus archives.)

The first Northern Virginia Community College graduation ceremony took place in 1967. Here, Robert McKee (second from left) and Dana Hamel (second from right) present diplomas to the first graduating class. McKee was the first president of NVCC from 1965 to 1967, and Hamel served as the founding chancellor of the Virginia Community College System from 1965 to 1979. Today, the Loudoun Campus continues to grow; from 2015–2016 to 2019–2020, the number of graduates at the campus increased by 21 percent, and those statistics have continued to trend upward in subsequent years. (Courtesy of NVCC Loudoun Campus archives.)

In 1980, Pres. Jimmy Carter visited the Loudoun Campus, where he signed the Reauthorization of the Higher Education Act. The act was originally signed into law in 1965 and was intended "to strengthen the educational resources of our colleges and universities and to provide financial assistance for students in postsecondary and higher education." President Carter's reauthorization extended the act through 1985. (Courtesy of NVCC Loudoun Campus archives.)

Virginia senator Charles Waddell speaks at the August 17, 1996, reception ceremony for what would be his namesake, the Waddell Building. Waddell was instrumental in securing funding for Phase II of the Loudoun Campus development. This building is in frequent use today and is also the site of the Waddell Art Gallery and the 230-seat Waddell Theater. Waddell shakes hands with Neil Reynolds, who was originally hired as dean of students at Northern Virginia Community College in 1969 and became provost of the Loudoun Campus in 1972. Of the honor, Waddell told the author in an interview, "It's amazing to me since I never got the opportunity myself to matriculate, that I got a college building named after me." (Both, courtesy of NVCC Loudoun Campus archives.)

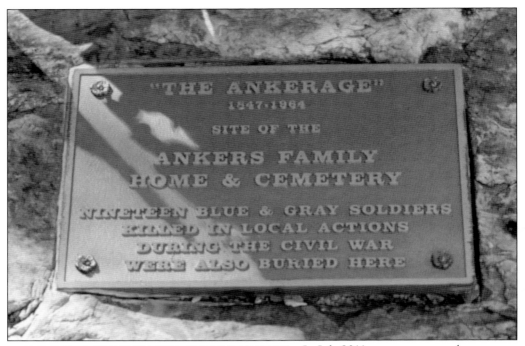

In July 2011, a ceremony on the Loudoun Campus of Northern Virginia Community College unveiled the Ankers Family Memorial Garden where a Virginia Civil War Trails marker and plaque were placed at the site of the Ankers family home and cemetery in remembrance of the "nineteen blue and gray soldiers killed in local actions during the Civil War [who] were also buried here." Samuel Ankers's second home, built in 1910 after his first home on the site burned down, was used as a temporary office for the school for a time but was eventually bulldozed in July 1976 as it no longer fit the architectural design of the campus. Prior to Ankers, in the 1820s, much of the land that today makes up the Loudoun Campus had been owned by Floushe Tebbs before it was willed to his son and then subsequently sold to George W. Miskell in 1851. Local historians have found uniform buttons engraved with the insignia of the 16th New York Cavalry on the NVCC site. (Above, courtesy of NVCC Loudoun Campus archives, Scott Matthews; left, courtesy of Michael Sorenson.)

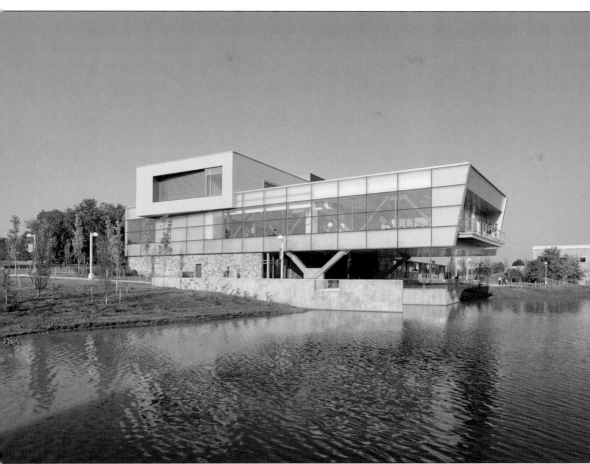

Today, the Loudoun Campus provides education to more than 11,000 students each year and has expanded to include eight buildings, two greenhouses, and a dog run. Under the auspices of the Loudoun Campus, the Reston Center opened for classes in spring 2006, and the Signal Hill Center opened for classes in the fall of 2009. In the fall of 2012, the Learning Commons building opened at the Loudoun Campus, followed by the opening of the Higher Education Center in 2015, which was renamed the Robert G. Templin Higher Education Center in 2016 after the college's fourth president. The Higher Education Center (pictured) was designed by Perkins Eastman and was certified as a Leadership in Energy and Environmental Design (LEED) Silver building in 2018. (Courtesy of Alan Karchmer/OTTO.)

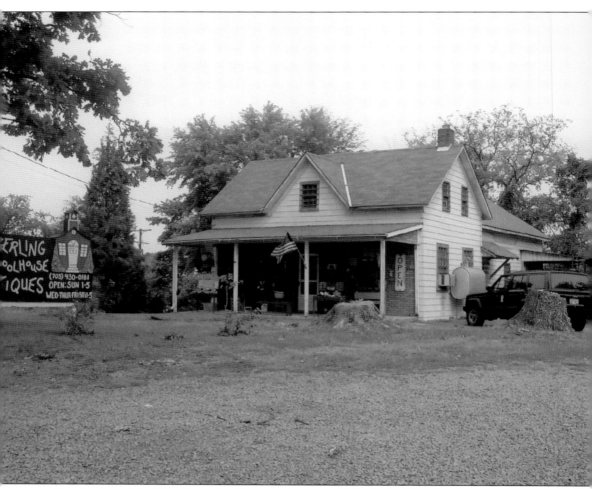

Despite the original Sterling schoolhouse's closure in 1947, the building has been used in several capacities in subsequent years. On January 15, 1982, Sterling Schoolhouse Antiques was opened by Betty Geoffroy, Bonnie Hayman, and Hugh Ball, and it operated until 2007. According to Margaret Testerman, "The schoolhouse had special significance for Hugh Ball, as he, his father, and his grandmother had attended Sterling School and he was a student the year the school was closed." The building has since been used by a landscaping company and heavy equipment operator to park vehicles. (Courtesy of the Crosen family archives.)

The Sterling Annex, the original Sterling Elementary School, is evidence of one of Sterling's cornerstone institutions falling into disrepair as the building deteriorated after years of unuse. Local blog *My Summer with Loudoun Schools* chronicled the building's worsening conditions over the course of more than 10 years. In 2020, Lindsay Automotive Group bought the property from Belfort Furniture with plans to raze the building in order to build a vehicle reconditioning center with space for outdoor vehicle storage. These photographs were taken shortly before the building's final demolition in August 2023. There have been talks that bricks would be saved to be reused in a pocket park on the property to memorialize the school. (Both, courtesy of Steve DeLong.)

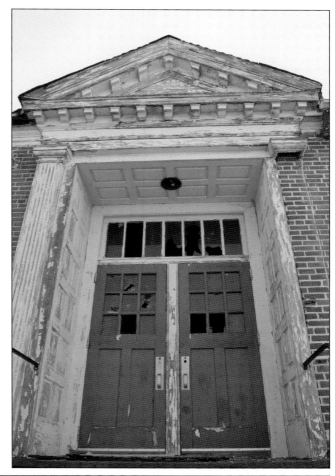

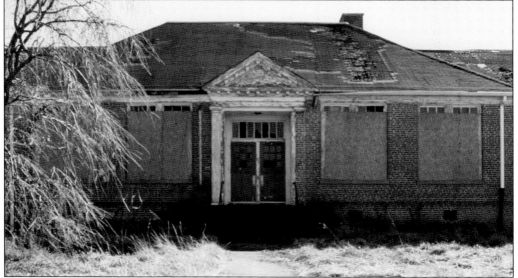

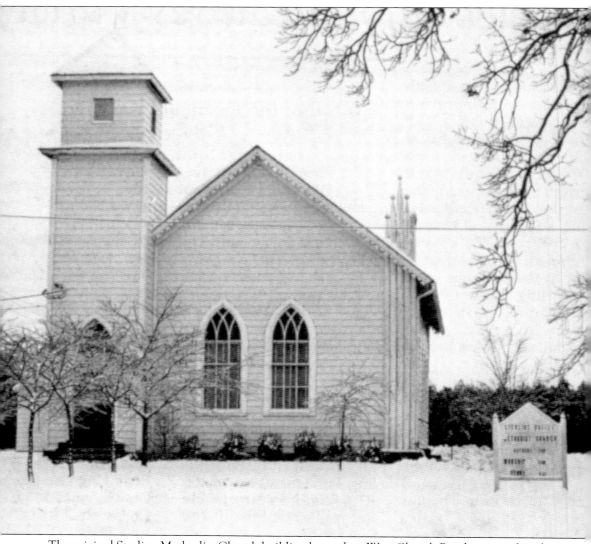

The original Sterling Methodist Church building located on West Church Road was another that succumbed to demolition in 2017. For several years, the structure housed a landscaping business until 2016, when a new owner purchased the property who sought and successfully received approval from Loudoun County to raze the church to construct a storage facility. The Sterling Historical and Heritage Preservation Committee worked to salvage some valuable and architecturally significant elements for preservation, such as the windows and German floorboards, with hopes of future reuse. (Courtesy of Claude Moore Park archives.)

In April 1996, the Friends of Claude Moore Park and the Loudoun Restoration and Preservation Society unveiled two plaques commemorating Vestal's Gap Road at a formal ceremony. The unveiling was dedicated to Sterling residents Carl and Helen McIntyre, who lobbied county officials and state legislators for two decades to protect what is left of the road. An artist's rendering shows the remaining segment of the colonial-era Vestal's Gap Road, including the main house, schoolhouse, tenant house, and barn, all still standing on the property. Vestal's Gap Road and the Lanesville Historic District were listed in the National Register of Historic Places in 2000. (Courtesy of Claude Moore Park archives.)

There are some success stories of Sterling structures being restored to their former glory. Benjamin Bridges's original 1870 schoolhouse at Claude Moore Park underwent an archaeological dig and extensive restoration starting in 2007. After sitting for many years, efforts to restore the oldest extant schoolhouse in Loudoun County included stabilization, foundation rebuilding, rotten beam replacement, chimney work, new exterior siding, and roof repair and painting. The work was completed in December 2013. While Loudoun County funded the roof work, the majority of financing was raised by the Friends of Claude Moore Park (FCMP), a volunteer organization that promotes the preservation and stewardship of the park. In 2014, Claude Moore Park was honored with the Community Blue Ribbon Award by the Loudoun County Joint Architectural Review Board in recognition of the efforts between the park and FCMP to preserve the schoolhouse. (Courtesy of Steve DeLong.)

Claude Moore Park provides a unique natural space amid the neighborhoods and commercial areas in Northern Virginia. It is considered one of the largest natural areas accessible to the public in the eastern part of Loudoun. In addition to the preserved historical elements, visitors can view an array of wildlife at the park's two fishing ponds or on 11 miles of hiking trails. The Loudoun Heritage Farm, also located on the park's grounds, is dedicated to preserving and promoting the rich agricultural history of Loudoun County. (Courtesy of Steve DeLong.)

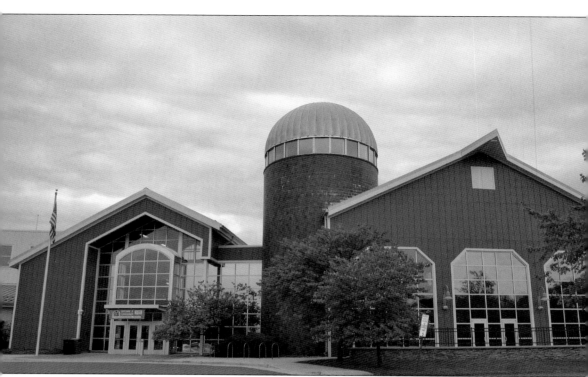

In 2007, the Claude Moore Park Recreation and Community Center, one of the first of its kind in Loudoun County, opened on the property. The center features competition swimming pools, an indoor water park, a rock climbing wall, and an indoor running track and gym. Adjacent to the center is the Sportsplex, which houses seven softball/baseball fields and two fields utilized for soccer, football, and lacrosse. The Claude Moore Park fields were recognized with the Pioneer Athletics Fields of Excellence Award in both 2011 and 2012 for being "among the best in the nation." (Courtesy of Steve DeLong.)

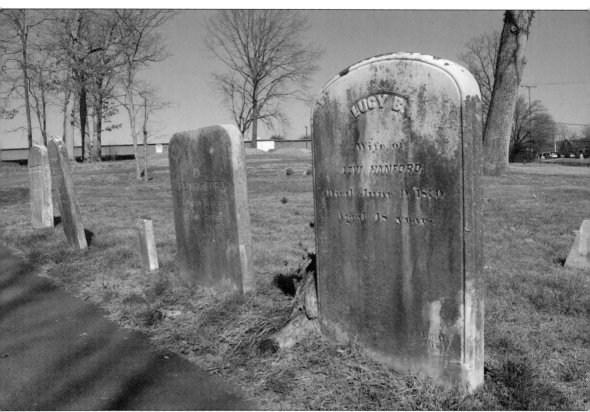

In April 2012, old Sterling Cemetery underwent a revitalization project to reinstall gravestones and improve the recording of tombstone information. The endeavor was designed and managed by David Lewis as part of his certification program for Eagle Scout. He drew up the plans and supervised a large group of his fellow Scouts from Troop 1173 along with parents and siblings. In 2020, the cemetery board approved preparations for the expansion of the cemetery. A fence was installed along Church Road and Cascades Parkway, and a new survey of the property was performed. Paving was also completed on the existing dirt road through the cemetery. (Courtesy of Steve DeLong.)

Since 1977, Sterling's library has been housed within the Sterling Community Center on Commerce Street. In 2017, a massive undertaking was completed when the library was relocated to the Sterling Park Shopping Mall. Loudoun County leased three abandoned storefronts and hired Grimm + Parker Architects to design and transform the 14,500-square-foot space into a modern, innovative library for the Sterling community. Grimm + Parker Architects added natural light elements to the 90-foot-deep space, incorporated café-style seating options, and installed a sculpted curved ceiling and a movable glass wall to keep the area open. The project earned Grimm + Parker Architects 2017 local and state/regional awards from the American Institute of Architects. (Courtesy of Sam Kittner and Grimm + Parker Architects.)

During initial planning for the library, several public meetings were held to incorporate community feedback. This led to a library designed to foster greater flexibility and inclusivity. The library has focused on hiring more Spanish-speaking staff, as Spanish is currently the second most spoken language in the Sterling area. A 2018 presentation at the Virginia Library Association highlighted that the library had hosted more than 1,000 programs with more than 20,000 attendees. These numbers have only continued to grow. The renovation of the library helped to also kick-start revitalization in the Sterling Park Shopping Mall and across Sterling Park with the community center and fire and rescue stations following suit. (Courtesy of Sam Kittner and Grimm + Parker Architects.)

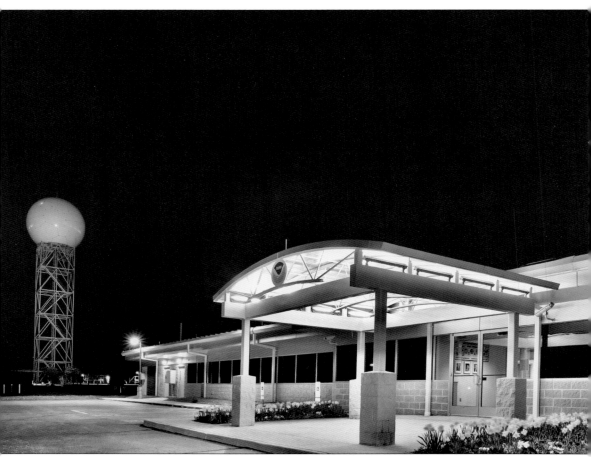

Sterling is also home to the National Weather Service (NWS) Weather Forecast Office serving the Baltimore-Washington metropolitan area, as well as the Sterling Field Support Center. The Sterling Field Support Center is dedicated to supporting and advancing the quality of meteorological observations taken by the NWS and other government agencies. The 230-acre complex was built as a test and evaluation facility in order to calibrate and support meteorological systems and sensors. Here the radar tower is seen in the distance. (Courtesy of National Oceanic and Atmospheric Administration [NOAA]/NWS, Robert Hyatt.)

BIBLIOGRAPHY

Bjorkman, Tom. "Claude Moore Park." *Loudoun Wildlife Conservancy*. July 1, 2003.

Edwin Washington Project. "Nokes Colored School, Sterling District." March 2, 2016.

Ford, Dorsey. "History of Education in Loudoun County." Honors thesis, University of Richmond, 1937.

Heppes, Roger. *History of the Lanesville Heritage Area*. Lanesville, VA: Lanesville Heritage Preservation Society of Claude Moore Park, 1999.

Grove, Noel, and Charles P. Poland Jr. *The Lure of Loudoun: Centuries of Change in Virginia's Emerald County*. Virginia Beach: Donning Company Publishers, 2007.

Guillaudeu, David A., and Paul E. McCray. *Washington & Old Dominion Railroad*. Charleston, SC: Arcadia Publishing, 2013.

History Matters, LLC. *Loudoun County African-American Historic Architectural Resources Survey*. The Loudoun County Board of Supervisors & the Black History Committee of the Friends of the Thomas Balch Library. September 2004.

Loudoun Times Mirror. "20 Years in Sterling Park." September 8, 1983.

Peck, Margaret C. *Washington Dulles International Airport*. Charleston, SC: Arcadia Publishing, 2005.

Poland Jr., Charles. *From Frontier to Suburbia*. Berwyn Heights, MD: Heritage Books, 2006.

Post Office Department Reports of Site Locations, 1837–1950. Washington, DC: National Archives and Records Administration, 1986.

Redmond, Edward. "Washington as Public Land Surveyor." Collection: George Washington Papers. Library of Congress.

Scheel, Eugene. *Loudoun Discovered–Communities, Corners, & Crossroads: Volume 1*. Leesburg, VA: The Friends of Thomas Balch Library, Inc., 2002.

Sterling Volunteer Fire Department. *Making Something Out of Nothing: A History of the Early Years 1966 to 1978*. August 9, 1993.

Stern, Neil V. "In Our Backyard: Preserve the Vanishing Vestal's Gap Road." *Loudoun Now*. January 24, 2019.

Stevenson, Brenda E. *Life in Black and White, Family and Community in the Slave South*. Oxford, UK: Oxford University Press, 1996.

DISCOVER THOUSANDS OF LOCAL HISTORY BOOKS FEATURING MILLIONS OF VINTAGE IMAGES

Arcadia Publishing, the leading local history publisher in the United States, is committed to making history accessible and meaningful through publishing books that celebrate and preserve the heritage of America's people and places.

Find more books like this at
www.arcadiapublishing.com

Search for your hometown history, your old stomping grounds, and even your favorite sports team.